The Art of
Painting
Flowers
in Oil & Acrylic

Quarto is the authority on a wide range of topics.
Quarto educates, entertains, and enriches the lives of our readers—
enthusiasts and lovers of hands-on living.
www.quartoknows.com

Authors: Marcia Baldwin, David Lloyd Glover, Varvara Harmon, Judy Leila Schafers,
and James Sulkowski
Page Layout: Britta Bonette

6 Orchard Road, Suite 100
Lake Forest, CA 92630
quartoknows.com
Visit our blogs @quartoknows.com

Printed in China
10 9 8 7 6 5 4 3 2

The Art of
Painting Flowers
in Oil & Acrylic

Contents

CHAPTER 1

Introduction

From delicate daisies to cascading foxgloves, a perfect plum blossom to a basket of vibrant zinnias, there's a veritable wonderland of floral beauty throughout *The Art of Painting Flowers in Oil & Acrylic*. In this easy-to-follow guide, five experienced artists reveal how they make garden landscapes come to life and floral still lifes sing. Step-by-step lessons demonstrate how to sketch a subject, create a convincing color palette, use light and shadow, and add dimension to a work of art. There is also an abundance of helpful reference information for beginning artists on getting set up, the principles of color theory, and techniques that will help take paintings to the next level. If your love for painting is in full bloom, it's time to get started!

Tools & Materials

You will see a vast array of items to choose from as you scan the shelves of your local art supply store. But there is no need to become overwhelmed; you will only need a few materials to begin painting. A good rule of thumb is to always buy the best products you can afford.

Buying Paints
You can use either oil or acrylic paint to complete the projects in this book. The main difference between the two mediums—aside from one being oil-based and the other water-based—is that acrylic dries much faster than oil, making it easier to paint over mistakes. Oil, however, has more pigment and renders richer colors. Both types of paint are available in two grades. "Artist grade" is the highest quality and contains the most pigment, whereas "student grade" is less expensive and contains more filler.

Selecting Supports
The surface on which you paint is called the support. Ready-made canvases are available in dozens of sizes and come pre-primed and either stretched on a frame or glued over a board Watercolor illustration boards work well with acrylic paint, providing a smoother surface. When working with oil paint, artists generally use canvas or wood. When using wood or any other porous material, you may need to add primer first to keep the paint from soaking through. Experiment with several different kinds of supports to see which best suits your own painting style.

CHOOSING A COLOR PALETTE

The nine colors shown below make a good basic palette. Each project in this book has its own palette, which you should review before purchasing paints.

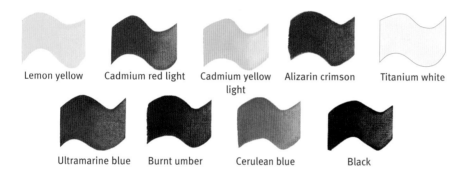

Lemon yellow | Cadmium red light | Cadmium yellow light | Alizarin crimson | Titanium white

Ultramarine blue | Burnt umber | Cerulean blue | Black

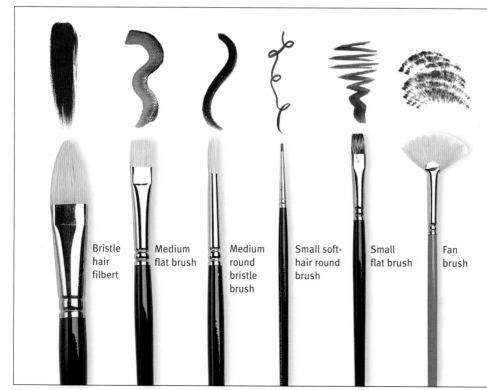

Bristle hair filbert | Medium flat brush | Medium round bristle brush | Small soft-hair round brush | Small flat brush | Fan brush

Buying and Caring for Brushes
There is no universal standard for brush sizes, so they vary slightly among manufacturers. Just get the brushes that are appropriate for the size of your paintings and that are comfortable for you to work with. The six brushes pictured here are a good starting set; you can always add to your collection later. Brushes are also categorized by the material of their bristles; keep in mind that natural-hair brushes are generally not recommended for use with acrylic paint.

OIL AND ACRYLIC MEDIUMS

You will want to purchase some mediums and thinners to accompany your paint—they are used to modify its consistency. Many different types of oil painting mediums are available—some act as thinners (linseed oil) and others speed up drying time (copal). Acrylic paint dries quickly, so you will want to keep a spray bottle filled with water handy. Another way to keep the paint moist is to add acrylic retarder. Don't use more than a 15-percent solution; too much retarder can cause uneven drying. There are a variety of oil and acrylic mediums available that achieve a wide range of effects. Visit your local art supply store and get acquainted with the possibilities.

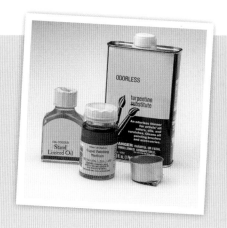

Picking a Palette
Whatever type of mixing palette you choose—glass, wood, plastic, or paper—make sure it's easy to clean and large enough for mixing your colors. You can purchase an airtight plastic box to keep your leftover paint fresh between sessions.

Finishing Up Varnishes are used to protect your painting—spray-on varnish temporarily sets the paint, and brush-on varnish permanently protects your work.

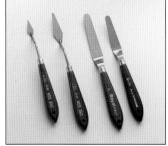

Using Painting and Palette Knives
Palette knives can be used either to mix paint on your palette or as a tool for applying paint to your support. Painting knives usually have a smaller, diamond-shaped head, and are well suited for applying paint directly to the canvas.

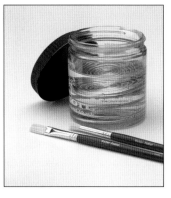

Cleaning Brushes A jar that contains a coil will save time and mess because it will loosen the paint from the brush. For removing oil paint, you need to use turpentine. Once the paint has been removed, you can use brush soap and warm water—never hot—to remove any residual paint. When painting with acrylic, use soap and water to remove paint from the brush. Reshape the bristles and lay flat to dry. Never store brushes bristle-side down.

Selecting an Easel The easel you choose will depend on where you plan to paint; for painting landscapes, you may want a portable easel.

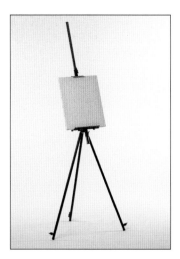

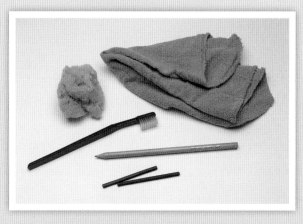

INCLUDING THE EXTRAS

Paper towels or lint-free rags are invaluable for cleaning your tools and brushes. They can also be used as painting tools to scrub in washes or soften edges. In addition, you may want charcoal or a pencil for sketching and a mahl stick to help you steady your hand when working on a large support. A silk sea sponge and an old toothbrush can be used to render special effects.

Color Theory

A color wheel can be a handy visual reference for mixing colors. All the colors on the color wheel are derived from the three primary colors—yellow, red, and blue. The secondary colors—purple, green, and orange—are each a combination of two primaries, whereas tertiary colors are mixtures of a primary and a secondary (red-orange and blue-green). Complementary colors are any two colors directly across from each other on the color wheel, and analogous colors are any three adjacent colors on the color wheel.

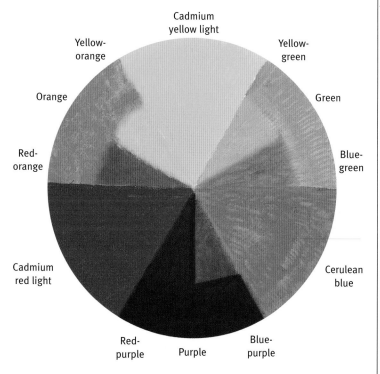

Tint (Added White)	Pure Color	Shade (Added Black)

Lemon yellow

Cadmium yellow light

Cadmium red light

Alizarin crimson

Cerulean blue

Ultramarine blue

Burnt umber

Complementary Colors

As noted above, complements are any two colors directly opposite each other on the color wheel, such as blue and orange. When placed next to each other, complementary colors create visual interest, but when mixed, they neutralize (or gray) one another. For example, to neutralize a bright red, mix in a touch of its complement: green. By mixing varying amounts of each color, you can create a wide range of neutral grays and browns. Mixing neutrals is preferable to using them straight from a tube because the colors will be closer to those found in nature.

Value

The variations in value throughout a painting are the key to creating the illusion of depth and form. On the color wheel, yellow has the lightest value and purple has the darkest value. You can change the value of any color by adding white or black. Adding white to a pure color results in a lighter value tint of that color, adding black results in a darker value shade, and adding gray results in a tone.

Color Temperature

Colors on the red side of the color wheel are considered "warm," while colors on the blue side are "cool." Warm colors convey energy and excitement, whereas cool colors evoke a calm, peaceful mood. Within all families of colors, there are both warm and cool hues. For example, a cool red contains more blue, and a warm red contains more yellow. Keep in mind that cool colors tend to recede, while warmer colors appear to "pop" forward. In a landscape, you can use this contrast to portray distance.

Mixing Color

Successfully mixing colors is a learned skill—the more you practice, the better you will become. One of the most important things is to train your eye to see the shapes of color in an object—the varying hues, values, tints, tones, and shades. Once you can see them, you can practice mixing them. If you're a beginner, you might want to go outside and mix some of the colors you see in nature at different times of day. Your ability to discern the variations in color under different lighting conditions is one of the keys to successful color mixing.

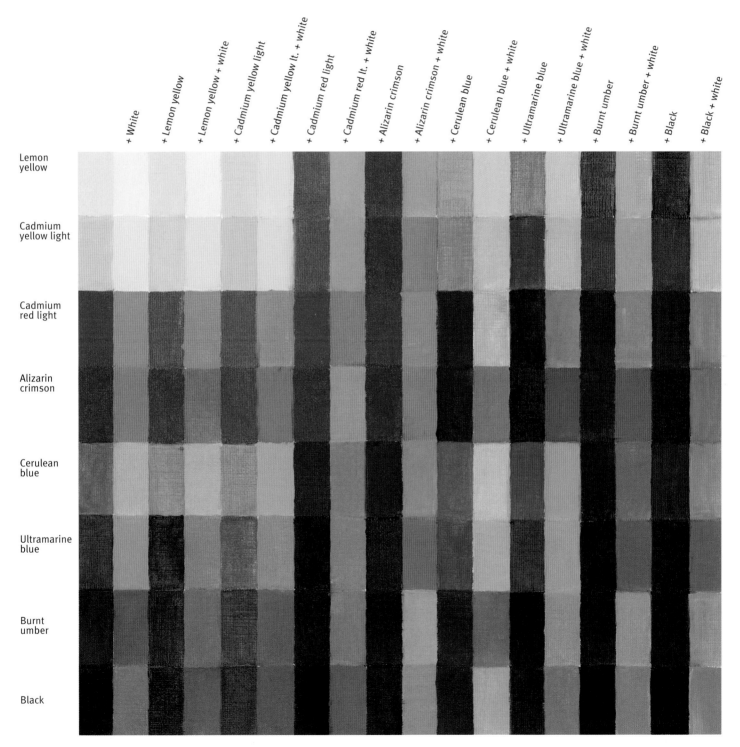

Using a limited palette This chart shows only a portion of the colors that can be made using the basic palette listed on page 8. To practice your mixing skills, create your own chart using the colors from your palette.

Drawing Techniques

While the focus of this book is on painting, it's important to hone your drawing skills so you can set yourself up for a successful painting from the start.

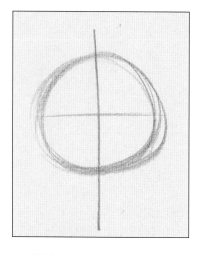 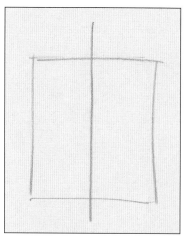

Using a Centerline

Using a centerline when drawing shapes can help you achieve accurate measurements and symmetry. Before sketching a basic shape, draw a vertical and/or horizontal line; then use the guideline to draw your shape, making sure it is equal on both sides. Remember: Drawing straight lines and uniform circles takes practice and time. As you progress as an artist, these basic skills will improve.

Establishing Proportions

To achieve a sense of realism in your work, it's important to establish correct proportions. Using centerlines, as shown above, will provide starter guidelines. From there, you must delineate the shape of the object. To do this accurately, measure the lengths, widths, and angles of your subject. Examine the vertical, horizontal, and diagonal lines in your subject and make sure they relate properly to one another in your drawing. You can check proportions and angles by using your pencil as a measuring tool. Use the top of your thumb to mark where the measurement ends on your pencil (A, B), or hold it at an angle to check your angles (C, D).

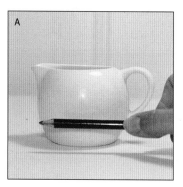 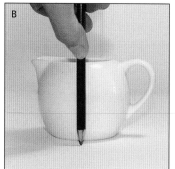 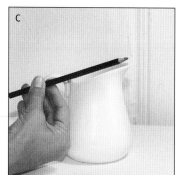 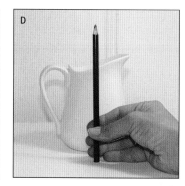

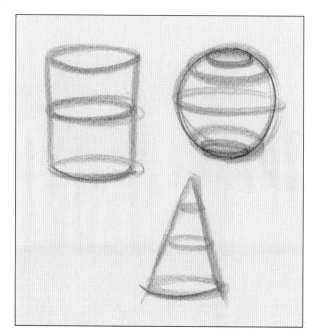

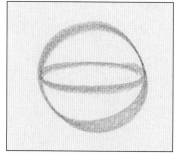

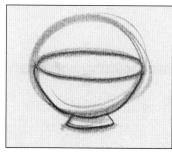

Drawing Through

You can transform basic shapes into forms by "drawing through" them. Imagine the form is transparent, and then suggest the surface of the backside in your sketch. This process will help you acknowledge the volume of your object as you add the surface shadows in later stages. It will also help you understand your object as it relates to its surroundings.

Values & Shadows

There are five main aspects of value that are used to create the illusion of volume. As mentioned previously, value refers to the tones of lightness and darkness, covering the full range of white through shades of gray to black. The range of lights and darks of an object can change depending on how much light hits the object. With practice, you will develop a keen eye for seeing lights, darks, and the subtle transitions between each value across a form. The five main values to look for on any object are the cast shadow, core shadow, midtone, reflected light, and highlight, as illustrated at right.

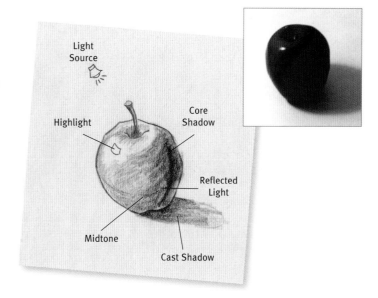

1. **Cast Shadow** This is the shadow of the object that is cast upon another surface, such as the table.
2. **Core Shadow** This refers to the darkest value on the object, which is located on the side opposite the light source.
3. **Midtone** This middle-range value is located where the surface turns from the light source.
4. **Reflected Light** This light area within a shadow comes from light that has reflected off of a different surface nearby (most often from the surface on which the object rests). This value depends on the overall values of both surfaces and the strength of the light, but remember that it's always darker than the midtone.
5. **Highlight** This refers to the area that receives direct light, making it the lightest value on the surface.

Focusing on Cast Shadows

Every object casts a shadow onto the table, chair, or surface that it sits upon (called the "cast shadow" as explained above). The shadow will fall to and under the dark side of the object, away from the light source. Including this shadow is very important both in depicting the illusion of form and in grounding your object, which gives the viewer a sense of weight and space. Note that these shadows are the darkest at the point where they meet the object (often beneath the object) and lighten as they move away from the object. Generally the shadow edge is also sharpest at the base of the object, softening as it moves away from the object.

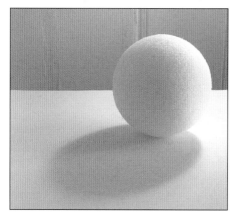

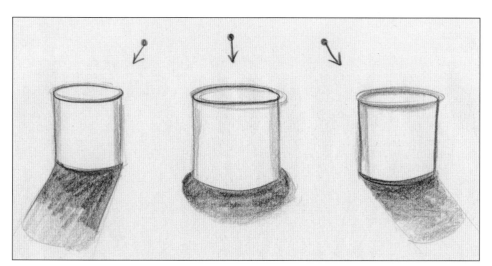

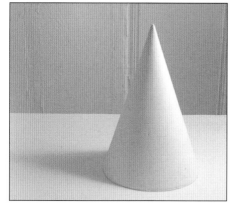

Oil & Acrylic Techniques

There are many different ways to approach a blank support. Some artists begin by toning (or covering) it with a thin wash of color. This "underpainting" provides a base for building colors, and sometimes it peeks through in the final painting. This process prevents your final artwork from ending up with unpainted areas. The underpainting is generally a neutral color; warm colors work well for earth-toned subjects, and cool hues suit most other subjects.

Working with Painting Tools

The way you hold your tool, how much paint you load on it, the direction you turn it, and the way you manipulate it will all determine the effect of your stroke. The type of brush you use also has an effect; bristle brushes are stiff and hold a generous amount of paint. They are also excellent for covering large areas or for scrubbing in underpaintings. Soft-hair brushes (such as sables) are well suited for soft blends, glazes, and intricate details.

Flat Wash To create a thin wash of flat color, thin the paint and stroke it evenly across your surface. For large areas, stroke in overlapping horizontal bands, retracing strokes when necessary to smooth out the color. Use thinned acrylic for toning your surface or using acrylic in the style of watercolor.

Drybrushing Load your brush and then dab the bristles on a paper towel to remove excess paint. Drag the bristles lightly over your surface so that the highest areas of the canvas or paper catch the paint and create a coarse texture. The technique works best when used sparingly and when used with opaque pigments over transparents.

Glazing As with watercolor, you can apply a thin layer of acrylic or oil over another color to optically mix the colors. Soft gels are great mediums for creating luminous glazes. Shown here are ultramarine blue (left) and lemon yellow (right) glazed over a mix of permanent rose and Naples yellow.

Dabbing Load your brush with thick paint and then use press-and-lift motions to apply irregular dabs of paint to your surface. For more depth, apply several layers of dabbing, working from dark to light. Dabbing is great for suggesting foliage and flowers.

Graduated Blend To create a gradual blend of one color into another, stroke the two different colors onto the canvas horizontally, leaving a gap between them. Continue to stroke horizontally, moving down with each stroke to pull one color into the next. Retrace your strokes where necessary to create a smooth blend between colors.

Scumbling This technique refers to a light, irregular layer of paint. Load a brush with a bit of slightly thinned paint, and use a scrubbing motion to push paint over your surface. When applying opaque pigments over transparents, this technique creates depth.

Artist's Tip

Use an old, dull pizza cutter to make straight lines; just roll it through the paint and then onto the support.

Painting Knife Applying paint with a painting knife can result in thick, lively strokes that feature variation in color, value, and height.

Scraping Create designs within your paint by scraping away paint. Using the tip of a painting knife or the end of a brush handle, "draw" into the paint to remove it from the canvas. For tapering strokes that suggest grass, stroke swiftly and lift at the end of each stroke.

Spattering First cover any area that you don't want to spatter with a sheet of paper. Load your brush with thinned paint and tap it over a finger to fling droplets of paint onto the paper. You can also load your brush and then run a fingertip over the bristles to create a spray.

Stippling This technique involves applying small, closely placed dots of paint. The closer the dots, the finer the texture and the more the area will take on the color and tone of the stippled paint. You can also use stippling to optically mix colors; for example, stippling blue and yellow in an area can create the illusion of green.

Sponging Applying paint by dabbing with a sponge can create interesting, spontaneous shapes. Layer multiple colors to suggest depth. Remember that you can also use sponges to apply flat washes with thinned paint.

Wiping Away Use a soft rag or paper towel to wipe away wet paint from your canvas. You can use this technique to remove mistakes or to create a design within your work. Remember that staining pigments, such as permanent rose (at right with Naples yellow), will leave behind more color than nonstaining pigments.

BLENDING LARGE AREAS

A hake brush is handy for blending large areas. While the area is still wet, use a clean, dry hake to lightly stroke back and forth over the color. Be sure to remove any stray hairs before the paint dries and never clean your hake in thinner until you're done painting, as it will take a long time to dry.

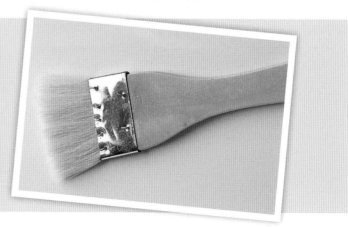

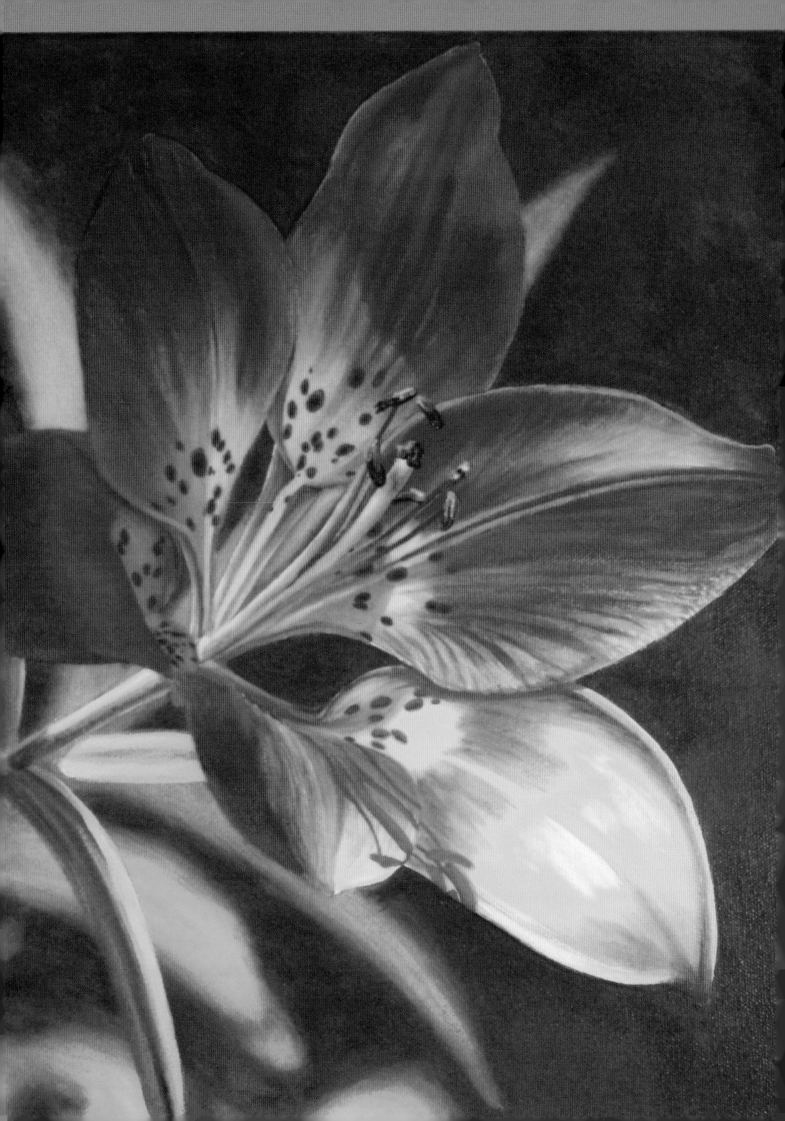

CHAPTER 2

Flower Portraits

with Judy Leila Schafers and Marcia Baldwin

Just as a portrait of a person must capture the personality of the sitter, a successful flower portrait must convey the unique characteristics and natural beauty of the subject. Colors should be true and textures accurate to the point that viewers can feel the flower simply by looking at it. The step-by-step lessons in this chapter show how to create dynamic flower paintings that achieve these important traits. They'll also inspire you to use your freshly honed skills to paint additional flower portraits with your own special touch.

Tiger Lily *with Judy Leila Schafers*

My attraction to the tiger lily is its vibrant color and simple yet dynamic design. There is ample opportunity here to practice working with reds and yellows in combination with dioxazine purple to re-create the subject's vibrancy without inadvertently muddying the colors.

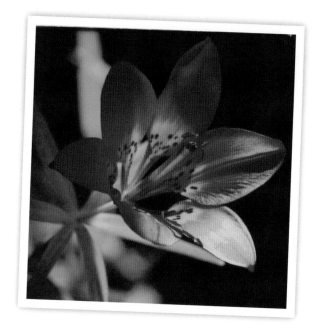

Color Palette

azo yellow • cadmium red medium • dioxazine purple
Indian yellow • lemon yellow
phthalo blue (red and green shade) • titanium white

Medium: acrylic polymer, glazing medium

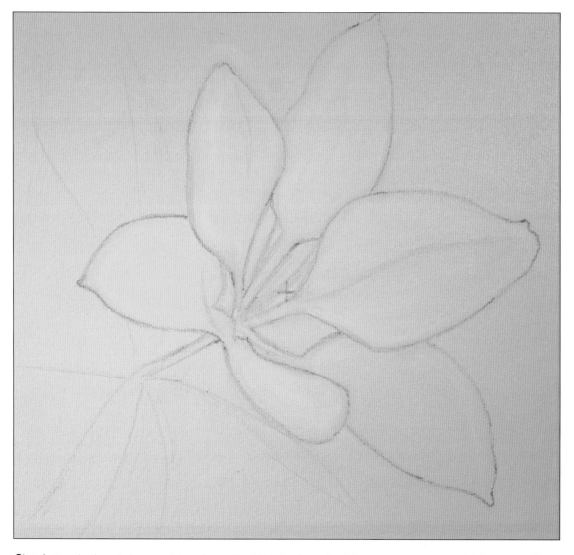

Step 1 To make the painting more interesting and highlight the flower itself, I use a square canvas, which I prepare with two coats of acrylic polymer medium. Once dry, I loosely paint the whole canvas with a mixture of glazing medium and azo yellow. This will help bring out the yellow in the image and give an overall feeling of warmth to the final painting. The coating doesn't need to be uniform, but it must dry thoroughly before continuing. Next I use a watercolor pencil to mark the center of the canvas, as well as my cropped reference photo. Now my focal point won't end up in the center of the canvas.

Step 2 Using various mixtures of dioxazine purple, phthalo blue green shade, cadmium red medium, titanium white, azo yellow, and glaze, I block in the background with a ¾-inch angle brush, being careful to preserve the flower. Random, quick strokes produce the illusion of texture—some of which will show through in the final painting—and creates interest without fussy detail. When this coat is dry, I add a few more layers of these mixtures, focusing on where the background should appear darkest. The more layers I add, the less streaky the painting appears. Limiting the number of layers on areas I find the texture most interesting will preserve some of it.

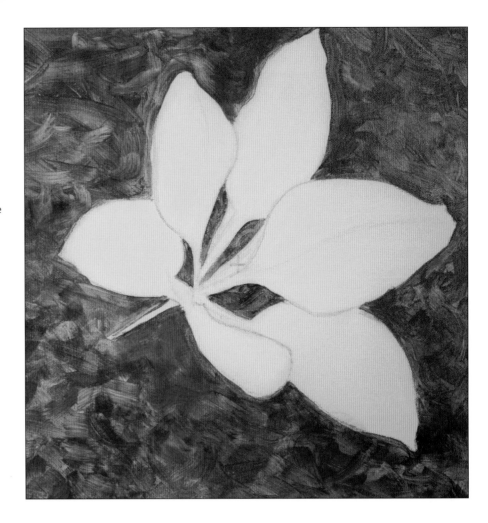

Artist's Tip

Always being aware of the directional markings of each petal helps add form and lifelike dimension to the flower.

Step 3 To suggest foliage in the lower left corner, I use a soft, worn ½-inch angle brush that is useful for creating blurred edges. I use mixtures of phthalo blue green shade, phthalo blue red shade, azo or lemon yellow, glaze, and a touch of cadmium red to paint the leaf shapes. For the darker greens, I add dioxazine purple to the mixture, and for the brighter greens, more lemon yellow; white create the highlights. I continue adding layer upon layer using a small amount of paint and working between mixtures until I capture the effect in the photo.

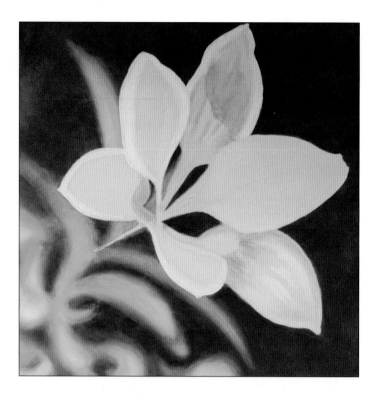

Step 4 I remove most of the watercolor pencil marks with a damp towel so they don't interfere when applying color to the edges of the petals. Next I paint a glaze of white onto the brightest parts of the petals. Mistakes in the original drawing are corrected using two to three layers of titanium white, straight from the tube. Once dry, I layer a coat of azo yellow over the white corrections to match the original petal shapes. Then I use Indian yellow to define the shadows in the petals.

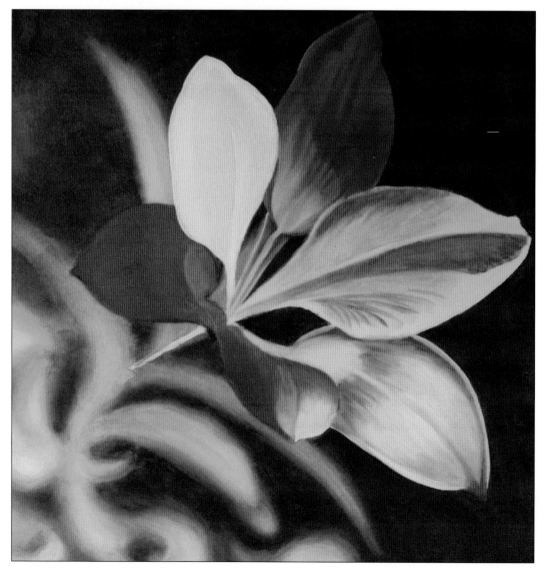

Step 5 Continuing with the petals, I use a mixture of glaze, cadmium red, dioxazine purple, and Indian yellow to deepen the darker shadows within the larger shadow shapes. When the paint dries completely, I add a layer of permanent rose mixed with glaze over the petal, except for the lightest sections. To these sections, I add a thin glaze of lemon yellow. I apply multiple layers of the yellow, red, and purple glaze mixture on the deeper orange petals using small amounts of paint until I achieve the desired depth of color.

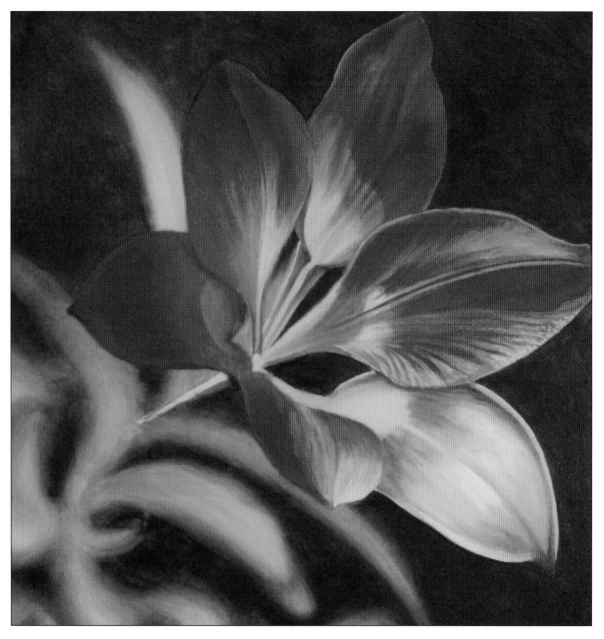

Step 6 Now I add a glaze mixture of purple, a touch of white, and permanent rose to the deep shadows of the flower. After it dries, I paint a few thin strokes of dark green (a mixture of phthalo blue green shade, dioxazine purple, azo yellow, glaze, and a touch of white) on the orange petals. These strokes can only be seen close-up, but subtly unite the flower with the background. In the lighter, more yellow shadow areas, I use a mixture of glaze, white, dioxazine purple, azo or lemon yellow, and a touch of permanent rose.

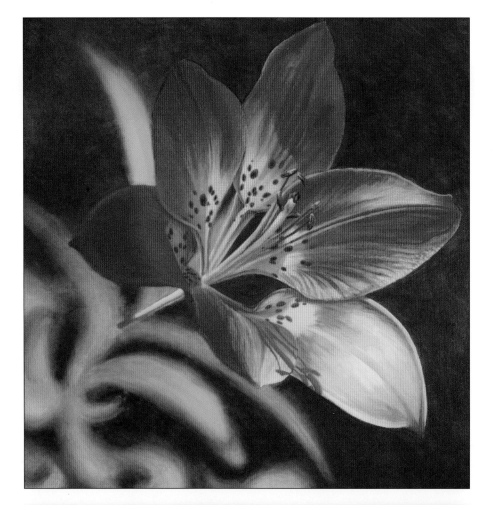

Step 7 In this step, I add freckles to the petals using a small size 0 liner brush and the shadow mixture of cadmium red, dioxazine purple, and Indian yellow. I also focus on developing the thin parts of each petal where they join to the stem. Next I use the liner brush to paint the stamens and pistil, building up layers until I'm satisfied with their color and form. Notice how the stamens and pistil cast an interesting shadow onto the bottom two petals. Finally, I add tiny dots of green and dark purple to the pistil and anthers to give the flower more dimension and help it harmonize with the background.

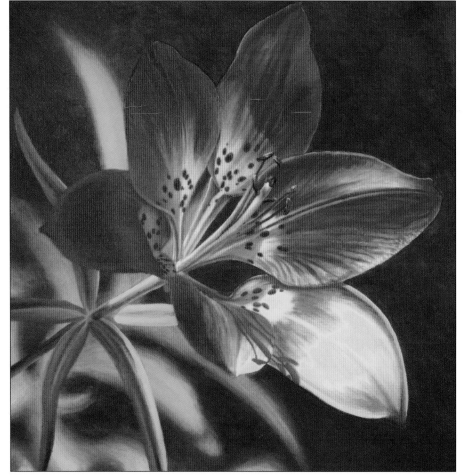

Step 8 Returning to the lower left corner of the canvas, I block in the stem and spear-shaped leaves with my dark green mixture, making sure the edges are sharply defined so they stand out from the background foliage. Then I add layers of lighter green mixes and streaks of bluish gray to create highlights within the shadows. For the sunlit leaves and stem areas, I layer on a mixture of white, lemon yellow, and a touch of phthalo blue red shade.

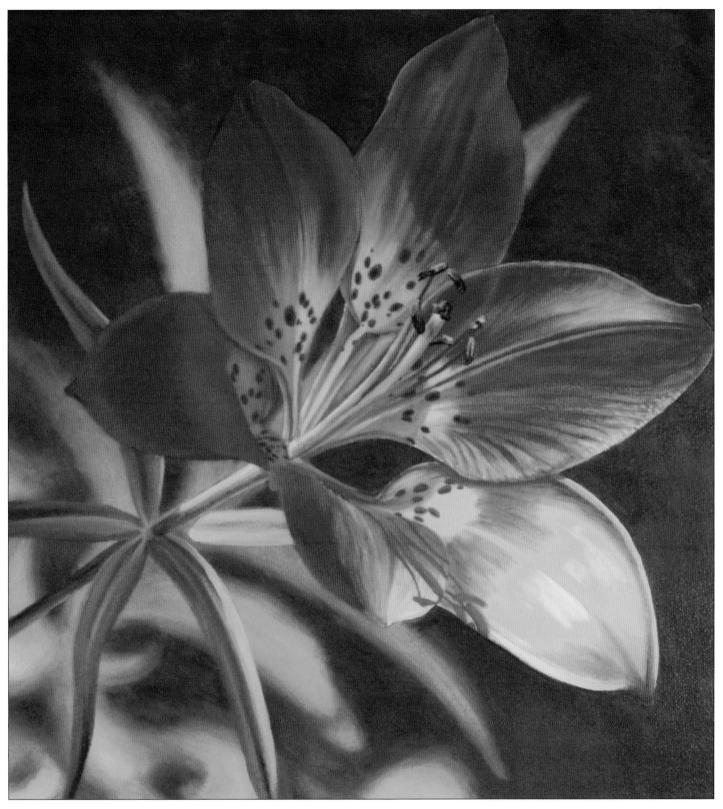

Step 9 I decide that adding another leaf to the background on the right side of the flower will help balance the composition. I tear a leaf-like shape from a piece of painter's tape and move it around to find the best location. Using the leftover foliage colors, I paint in the extra leaf, making sure to keep the edges soft so it doesn't draw too much attention. Next I glaze on patches of strategically placed cadmium red, as well as the purple and white glaze mixture. This further harmonizes the flower with the background while creating balance and breaking up larger areas of dark color. Now the painting feels complete!

Pansy *with Judy Leila Schafers*

Because so much of the pansy's charm is due to its distinctive face-like markings, I opted for a square format that would both draw attention to the main flower and make the composition more striking. Although it requires a bit of effort, you'll find that taking the time to play with the layers of petals and colors until you're completely satisfied is worth your while.

Color Palette

azo yellow • dioxazine purple • hansa yellow
lemon yellow • phthalo blue (red and green shade)
quinacridone magenta • quinacridone violet
titanium white

Medium: acrylic polymer, glazing medium

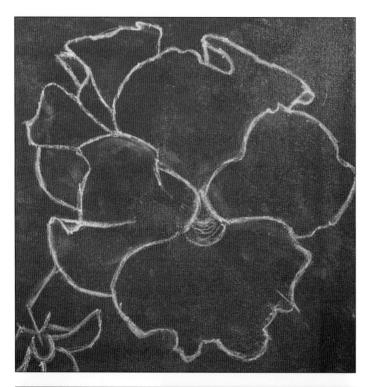

Step 1 I prepare the canvas with two coats of acrylic polymer medium and allow them to dry. Then I loosely paint the whole canvas with a mixture of glazing medium, dioxazine purple, phthalo blue (red and green shade), a bit of hansa yellow, and a touch of titanium white. Don't worry about the color or applying the coating uniformly. But do let the canvas dry thoroughly before continuing. After it has dried, I use a yellow watercolor pencil to draw the main parts of the image. With a midsize brush, I also loosely paint thin leaf shapes and shadows onto the background.

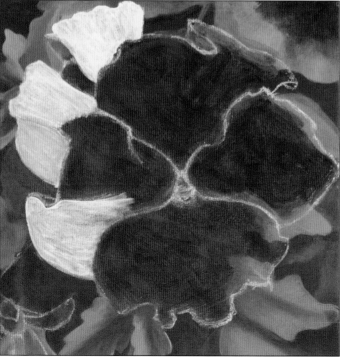

Step 2 Next I block in the farthest back petals of the pansy with a thin coating of titanium white, correcting its shape where I see fit. This process makes the colors added later appear more brilliant. I use a thicker coating of white under sections with the brightest colors. While that dries, I continue working on the leaves in the background. I cover the farthest back petal with a coat of quinacridone magenta and let it dry. On the next petal, I apply a few coats of titanium white, making it thicker where the light is brighter. When the first petal is thoroughly dry, I add a layer of dioxazine purple mixed with glazing medium and a touch of white to the outer fringe using a soft brush and light pressure.

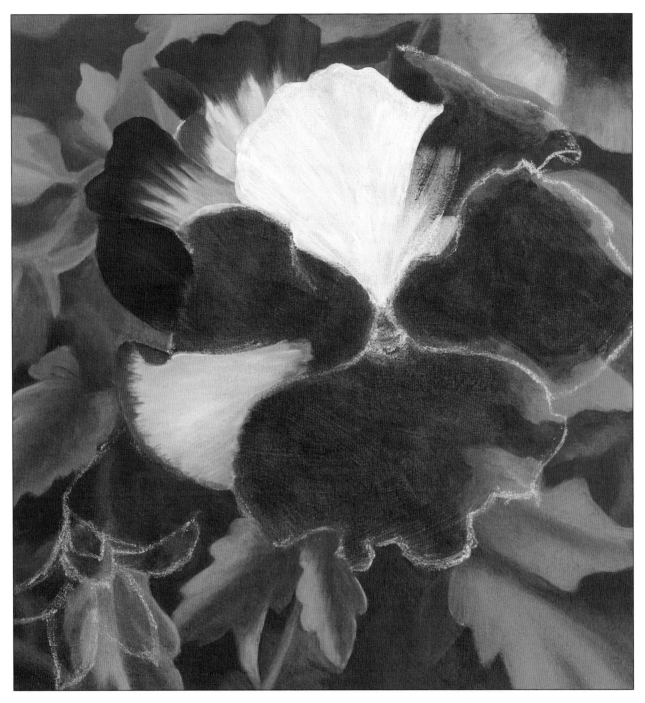

Step 3 Still using a soft brush and light pressure, I add a layer of quinacridone violet mixed with a some white and glazing medium to the outer fringe of the second petal. Then I paint the yellow portion with azo yellow and the shadow sections with azo yellow and dioxazine purple. I return to the first petal and add a layer of quinacridone violet mixed with white and glazing medium. Moving to the second petal, I apply a layer of dioxazine purple mixed with a touch of white and glazing medium over the violet fringe. When it's dry, I add another coat of quinacridone violet, working back and forth between these colors until I reach the desired effect. Finally, I add quinacridone magenta to the shadow parts of the fringe and add another layer of yellow to complete the petal.

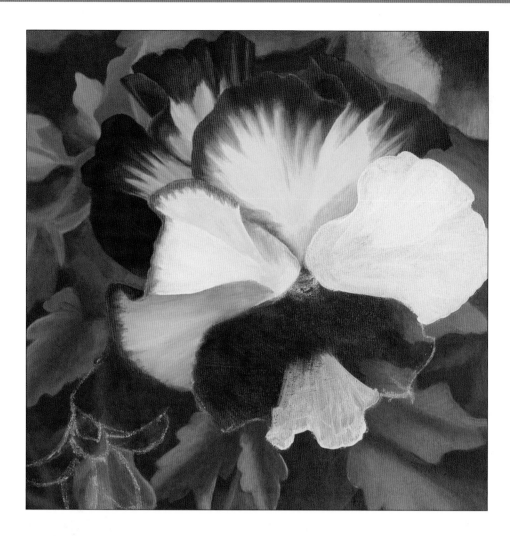

Step 4 I approach each petal in the same way I approached the first three, working back and forth between each color layer until the desired effect is achieved. The area should appear less streaky with each layer. Be careful not to add too much paint, which will result in the area becoming too dark.

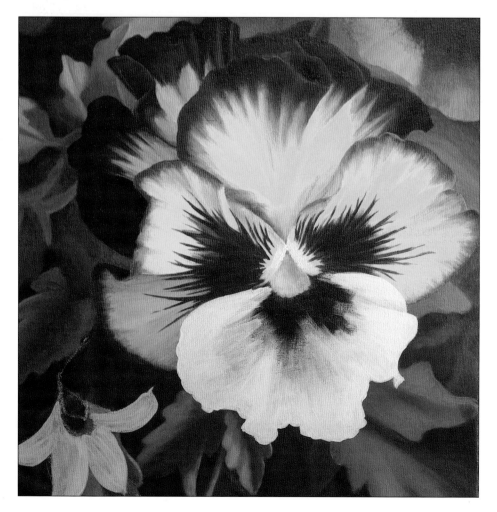

Step 5 Corrections can be made at any time by applying a layer of white and then reworking the area. (Warning: An excess of paint may create unwanted ridges.) I adjust the bottom petal's shape after realizing it should be much larger. Then I complete the rest of the flower in the same way, taking note of shadows, highlights, and subtle color nuances. I apply paint most heavily in the center of the flower. The brightest whites include a tiny bit of lemon yellow.

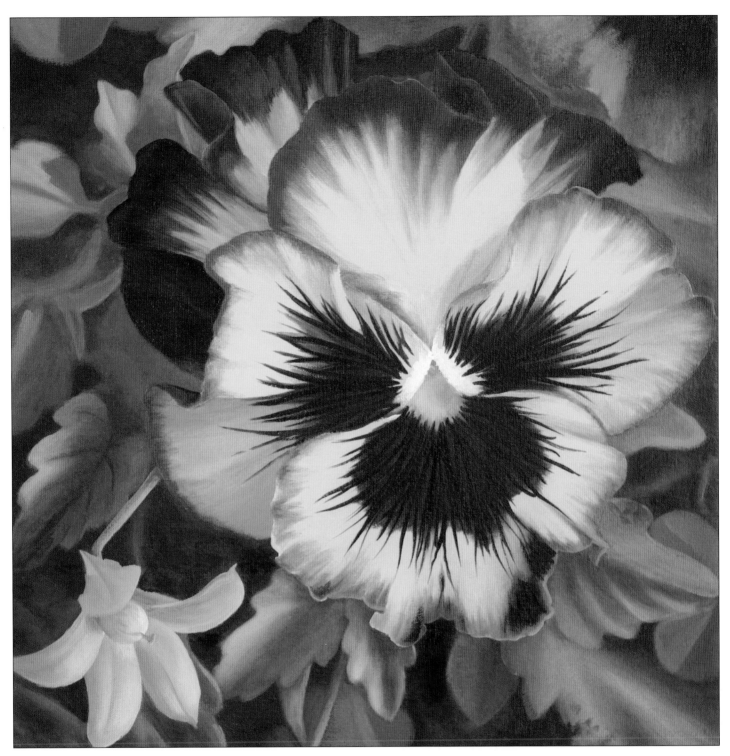

Step 6 Here I return to the background, keeping the direction of the light source in mind as I refine shapes, shadows, and highlights. I coat the seedpod with several layers of a mixture of lemon yellow, phthalo blue green shade, white and dioxazine purple, and glazing medium. I also include some suggestions of the blue lobelia in various locations to add color variety and interest to the background. Then I paint in a few areas of these simple flower shapes using phthalo blue red shade, dioxazine purple, quinacridone violet, and a bit of lemon yellow, using more white and violet on the highlight side. Finally, I darken some areas of the background to create depth. After a few tweaks, the painting is complete!

Harebells *with Judy Leila Schafers*

The flowing shapes and calming color of these delicate flowers appealed to my painter's eye. However, the play of light, as well as the withered flower near the end of the stem, presented some interesting color and compositional challenges. To capture their true beauty, we'll begin with a rectangular canvas that suits how harebells grow and allows room for an appropriate background without too much empty space.

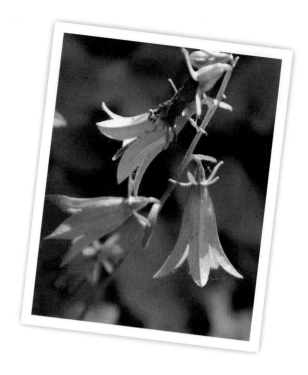

Color Palette

azo yellow • cadmium red • dioxazine purple
Indian yellow • lemon yellow • permanent rose
phthalo blue (red and green shade)
quinacridone magenta • titanium white

Medium: acrylic polymer, glazing medium

Step 1 I sand my 12" x 16" canvas and cover it with two layers of acrylic polymer medium . Then I loosely cover it with a mixture of glaze, dioxazine purple, white, phthalo blue green shade, and a touch of azo yellow. After it is completely dry, I use a light yellow watercolor pencil to draw the stem of flowers. I then consider the position of each bell and make changes to improve the composition. For now, I omit the blurry flower that appears above and left of the bottom flower in the photo.

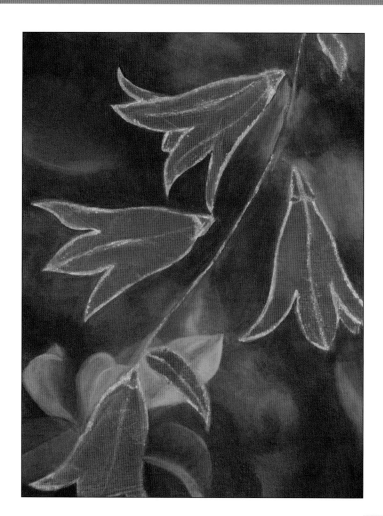

Step 2 Using a ¾-inch angle brush, I loosely block in the background with a dark mixture of glaze, dioxazine purple, phthalo blue green shade, azo yellow, and a touch of white and cadmium red. (Adding white to the mix creates a sense of depth when the more saturated colors are painted into the foreground.) For the brighter, midtone green foliage shapes, I use a mixture of phthalo blue green shade, azo yellow, glaze, a bit of dioxazine purple, and a touch of white. For the light greens I add lemon yellow, a touch of permanent rose, and more white to the midtone green mixture. I purposely mix plenty of these colors to use later in the painting. Leaving a few areas with the original purple showing through will help tie all the elements together in the final painting.

Step 3 When the background is completely dry, I use a dampened cloth to remove most of the watercolor pencil markings. This prevents the watercolor pigment from mixing with the flower colors. Next I use titanium white to loosely paint the brightest highlights on the top three flowers and the bud. I then paint in a layer of quinacridone magenta, white, and glaze mixture on the pinkish parts of each flower. Finally, I apply the main colors on the small leaf just above the bottom flower.

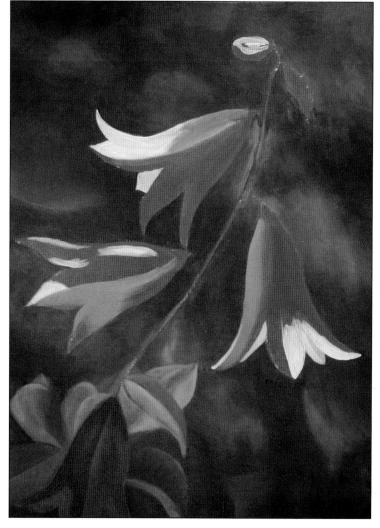

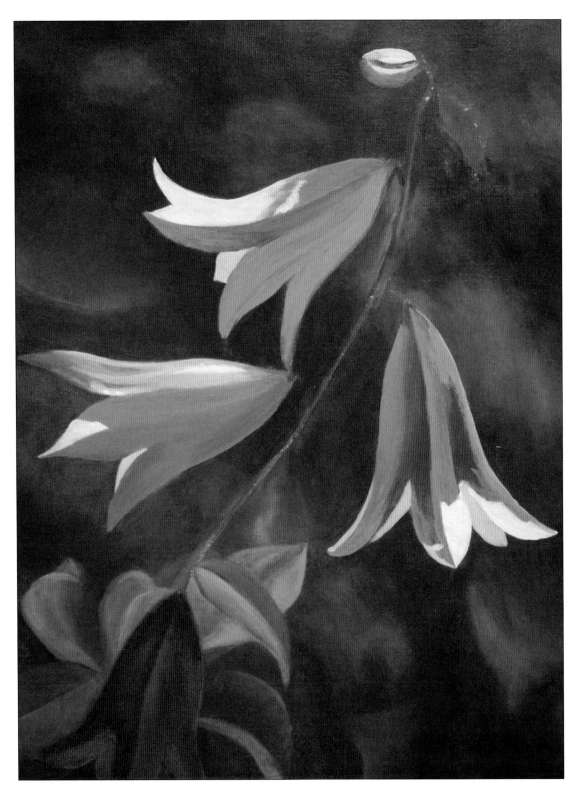

Step 4 Now I create mixtures for the predominant colors on the flowers using phthalo blue red shade, phthalo blue green shade, dioxazine purple, white, a touch of quinacridone violet, and a bit of glaze. For the lighter parts of the flowers, I add more white, and for the deeper shadows, more phthalo blue green shade and dioxazine purple. Moving to the two bells at bottom left, I glaze on a thin layer of midtone purple over the whole flower, leaving the white highlights uncovered. Once dry, I add the shadow color in the appropriate areas. Then I adjust the mixtures as necessary by adding more blue, white, or purple. Using the photo as a guide, I decipher the subtle differences in color and value within each flower and add these paint mixes to the other bells.

Artist's Tip
To minimize the formation of streaks, use a small amount of paint and light pressure on a very soft brush.

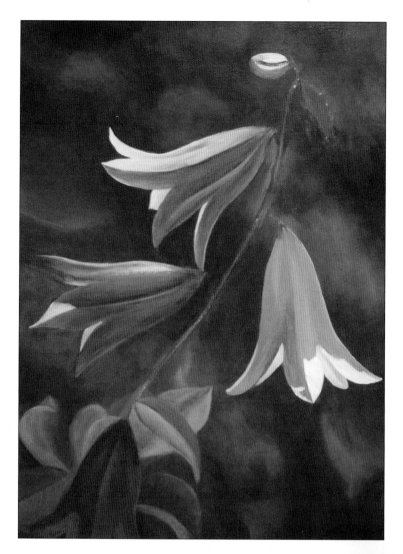

Step 5 To achieve depth of color on the flowers, I apply a thin glaze of dioxazine purple made with glaze and a touch of white, leaving the brightest highlights uncovered. Over the sunlit portions, I apply a pale glaze of white and a bit of lemon yellow and quinacridone magenta, using the photo as a guide for refinements. Plain white often results in a graying effect that would make these sunlit sections appear cool and distant. Some areas require more coats of glaze.

Step 6 I refer to my photo as I paint the highlights and shadows in the bud. I add a touch of green on the underside and some lighter purple-blue mix on the side facing left. After I render the withered flower shape with the midtone purple mix, I apply layers of dioxazine purple to deepen the color. Where I imagine the sun would illuminate its form, I add patches of white and layer on glazes of dioxazine purple with magenta and a bit of white. The bottom flower is too dark, so I lighten it with thin glazes of midtone purple mixed with a little more white.

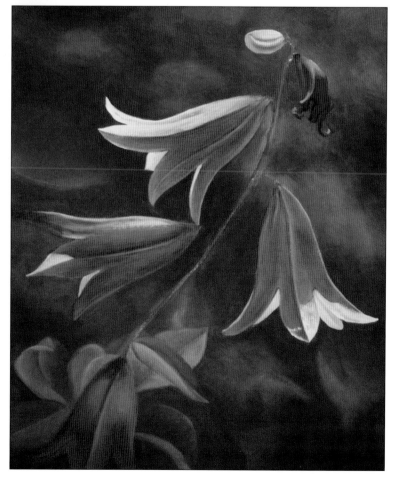

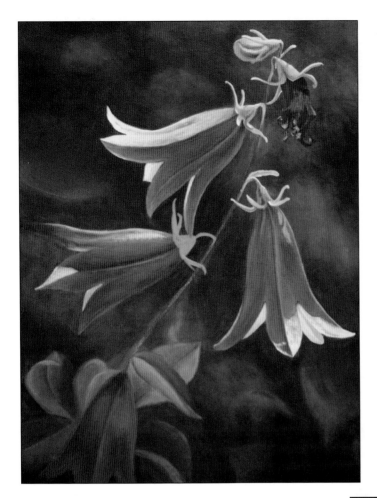

Step 7 Here I use a liner brush to block in the calyxes (green caps on the flower tops) with a midtone green made of phthalo blue green shade, azo yellow, dioxazine purple, glaze, and a touch of white. To better suit the size of its calyx, I enlarge the withered flower and refine the highlights and shadows. Adding detail with Indian yellow and the purple-blue mixture completes it. I continue working on the calyxes, paying attention to their variation of colors and patterns. Then I paint the top half of the main stem to accurately represent the light source and variation of color along the length of the stem.

Step 8 There is too much space between the bottom flower and the one on the left, so I block in the blurry flower that faces away from the viewer in the photo with a darker version of the midtone purple mixture. Once dry, the color on the new addition is too saturated and dark, making it appear to be in front of the other flowers. To correct this, I add layers of the lighter purple mixture and keep the edges soft and blurred. It still draws too much attention, so I glaze on a thin layer of midtone green to optically push it toward the background. I also change the bottom flower's angle to improve the rhythm in the composition.

Artist's Tip
View the painting in a mirror to better see where tweaks that will strengthen the painting should be made.

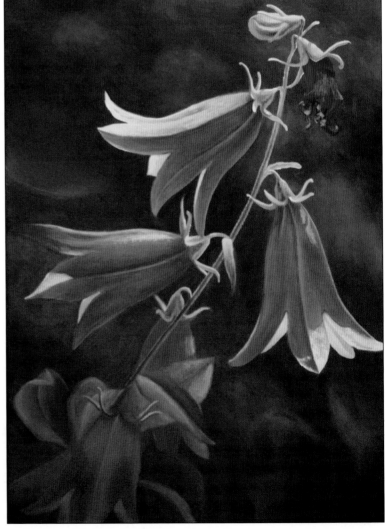

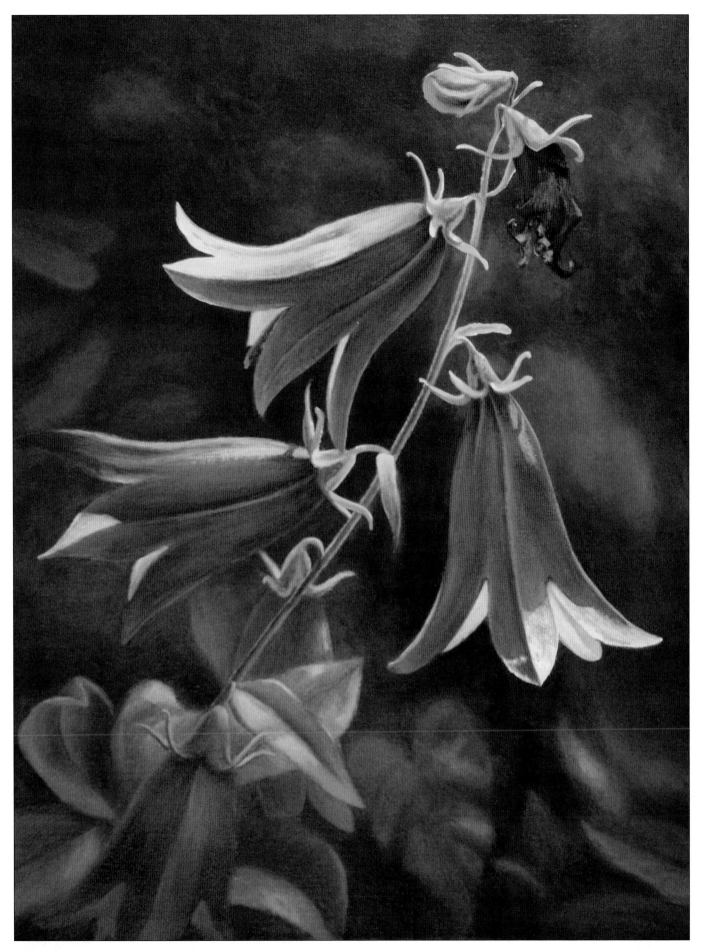

Step 9 The background needs more interest and lacks cohesiveness in relation to the forefront. I create a stronger focal area by darkening some of the areas around the flower closest to the right edge of the canvas, continuing on both sides of the stem and around the front of the top bell. Then I add more foliage shapes, keeping the colors fairly muted and the edges soft using very light pressure and minimal paint on a soft brush. I add brighter highlights and shadows to the leaves at the left of the painting. Next I lighten the bottom flower a bit more with glazes of the lighter purple mixture and quinacridone magenta. I make a few adjustments until the beauty of these harebells has been realized.

Plum Blossom *with Judy Leila Schafers*

This plum blossom exudes the beauty and freshness of spring, and possesses a gorgeous range and depth of color that is great fun to paint. In this project, we'll strengthen the composition by adding balance, as well as a lower branch that will lure the viewer's eye into the painting.

Color Palette

azo yellow • cadmium red • dioxazine purple
hansa yellow • Indian yellow • permanent rose
phthalo blue (red and green shade)
quinacridone magenta • titanium white

Medium: acrylic polymer, glazing medium

Step 1 After sanding my 16" x 20" canvas and coating it with two layers of acrylic polymer medium, I layer on a mixture of permanent rose, white, and glaze. I paint this on loosely, intentionally creating some texture that will show through in the final painting. When dry, I mark the center of both the canvas and the photo. Then I use a watercolor pencil to draw in the composition, spending extra time on the complicated parts of the flower. Extending the branch downward and to the left of the canvas helps lead the eye into the painting while anchoring the blossom. I move some elements closer together because the photo and the canvas are not proportional.

Artist's Tip

A wet cotton swab serves as a good eraser for correcting errors in the intricately detailed sections of the painting.

Step 2 When I'm satisfied with the drawing, I mix the background colors. The dark tones are created with phthalo blue red shade and green shade, dioxazine purple, azo yellow, a touch of white, glaze, and a bit of cadmium red. The midtone green is a mixture of azo yellow, both phthalo blues, dioxazine purple, glaze, and a little white. I add more hansa yellow and white for the brighter greens. For the pinkish gray, I use white, permanent rose, dioxazine purple, phthalo blue green shade, glaze, and a touch of hansa yellow. Next I roughly block in the background, creating more texture as I go along. Allowing some of the original base color to show through in a few areas suggests flowers in the distance. To create the fuzzy shapes, I make a circular motion with a soft ½-inch angle brush loaded with a small amount of paint.

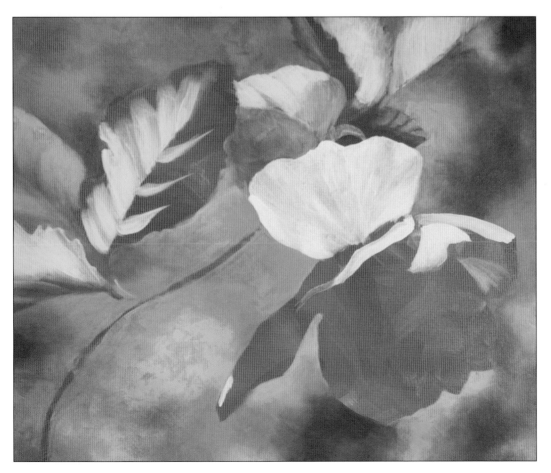

Step 3 On the now dry background I block in the lightest parts of the leaves with a few layers of hansa yellow and white mixture, using heavier paint in the brightest places. Next I loosely fill in the leaves positioned a bit farther back, as well as the small leaves directly above the large petal. While these sections dry, I coat the lightest parts of the blossom with titanium white, again using thicker paint where the lighting appears brightest in the photo. Leaving just enough to preserve the flower drawing, I remove most of the blue watercolor pencil markings with a damp cloth.

Step 4 Here I work on the dark parts of the leaves closer to the foreground, filling in all but the yellow ribs with a mixture of phthalo blue green shade, dioxazine purple, hansa yellow, glaze, and a bit of white. I make sure to use enough paint to cover most of the original pink tones. Then I add the green ribs to the rest of the foliage. When they're completely dry, I coat the leaves in azo yellow mixed with a bit of glaze to soften and warm their tone. Finally, I block in the light blue-green highlights on the leaf edges with a mixture of white, hansa yellow, phthalo blue green shade, glaze, and a dab of permanent rose, keeping the edges soft.

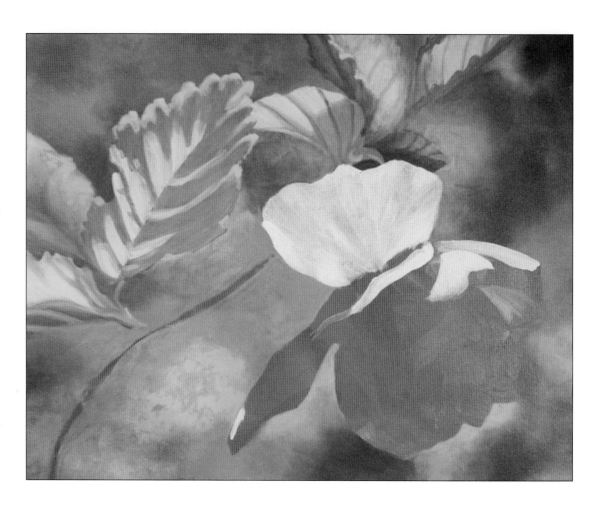

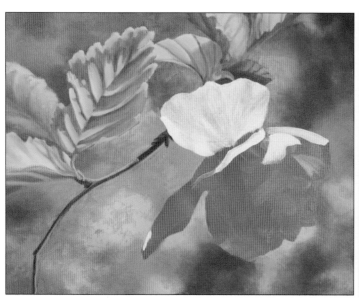

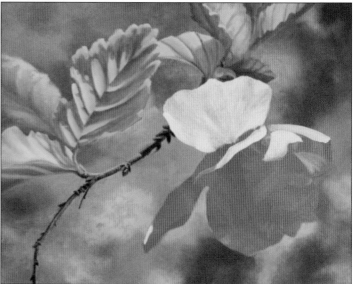

Step 5 To create the effect of light penetrating the leaves, I cover the yellow parts with a mixture of glaze and phthalo blue green shade using a soft brush and light pressure as I follow the grain lines. I use the same method to thinly coat the sections in deep shadow. Making sure each coat is dry before proceeding, I add layers of azo yellow or phthalo blue green shade until I achieve the desired effect. Next I address the branch that extends toward the bottom left of the canvas. Using a mixture of dioxazine purple, Indian yellow, white, and a bit of phthalo blue green shade, I block in its basic shape, including some of the nodules. I add more white and permanent rose to the mixture for the highlights. I'll come back and refine this section after the background is complete.

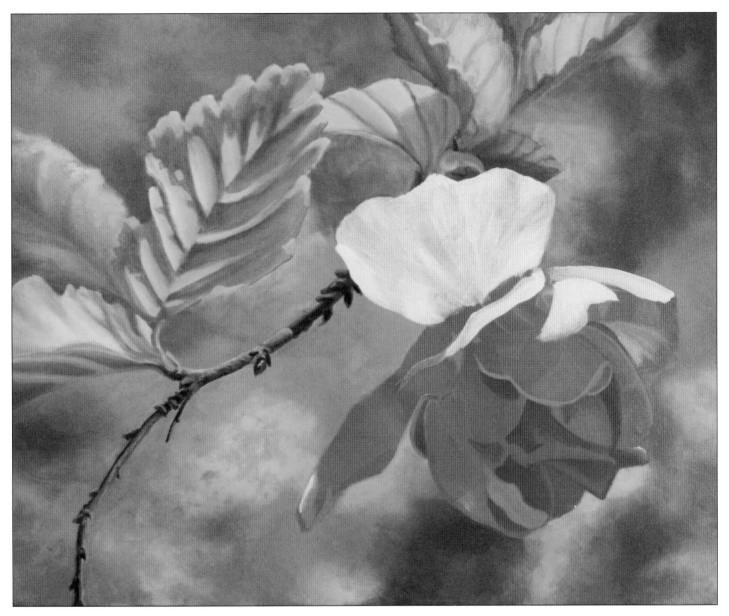

Step 6 Now I work on the blossom, mixing ample quantities of the main colors. For the deep shadow mix, I add quinacridone violet, permanent rose, glaze, and a touch of white and dioxazine purple. The midtone pink shadows are a mixture of white, quinacridone violet, dioxazine purple, glaze, and varying amounts of white and permanent rose. Next I cover the smaller shapes at the bottom of the flower, letting each layer dry before adding another coat. Using the photo as a guide to possible variations within each shape, I move to other petals with a similar color range. I fill the dark shape between the main flower and the lower left petal with midtone green and quinacridone violet. Because color corrections can be made later, I move into the center of the flower, coating these shapes with the deep shadow. Then I layer them with touches of Indian yellow and traces of midtone green.

Artist's Tip

It's very common and often a necessity to adjust color
mixes as the paint dries and the painting progresses.
Go with your instincts!

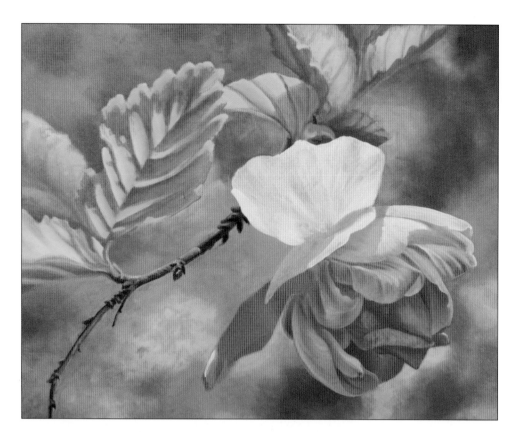

Step 7 As the petals lighten in color, I add more white paint to the basic midtone shadow mix, as well as varying amounts of permanent rose, quinacridone violet, or dioxazine purple. I also layer white over the areas of direct sunlight, obscuring the first layer of pink. Then I apply Indian yellow and permanent rose to certain areas in the center of the blossom, followed by dashes of lime green or a phthalo blue green shade and white mix. These colors are applied using a drybrush technique and a very small amount of paint. They add punch to the flower, help harmonize it with the background and the leaves, and break up the monotony of the pinks.

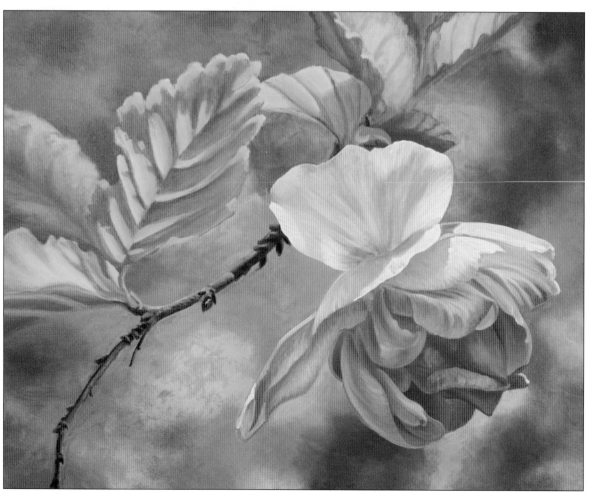

Step 8 Continuing with the top three left petals, I block in the shapes with a lighter version of the midtone shadow mix, leaving the brightest white parts uncoated. Then I prepare a blue-gray mixture using white, phthalo blue green shade, a touch of hansa yellow glaze, and of permanent rose. For the pinkish-gray tones I use white, a touch of Indian yellow, a bit of dioxazine purple, quinacridone violet, and a dab of phthalo blue green shade. Again, I refer to the photo for interesting color variations within each petal. In the brightest sunlit sections, I layer on a very thin coat of cadmium red mixed with glaze to warm up the white and enhance the sunny glow.

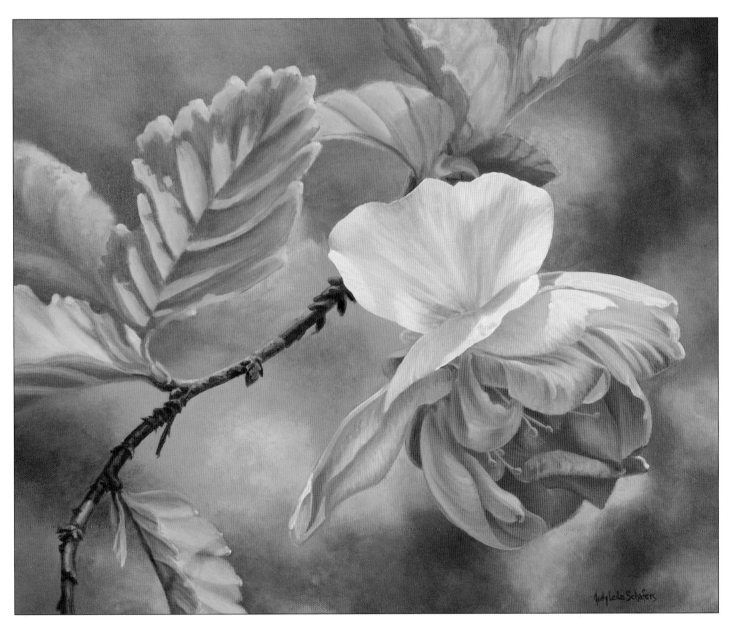

Step 9 As I study the background, I notice some of the colors are too saturated and some of the shapes should be reworked. There is also too much pink showing through, which competes with the flower. The highlights on the lower branch are inaccurate, so I move them to the center of the branch. I wonder if there is too much empty space in the lower left corner of the painting, so I stick a piece of painter's tape on the canvas where a leaf might naturally appear. After some consideration, I paint in this shape using the same colors and process used for the other leaves. The addition brings more balance to the composition and helps anchor the main subject. Looking closely at the photo I see two small shapes below the left side of the large top petal, which are, presumably, the blossom's calyxes. I paint them in using leftover leaf and flower colors. Lastly, I add the yellow stamens that project from the flower's center and declare the painting complete.

Fuchsia *with Marcia Baldwin*

The first stage of any painting starts with inspiration, followed by a plan for rendering a subject. I seek out gardens, floral displays, or photos for ideas when starting a new painting. I play around with compositions in my mind's eye and make sketches to guide me as I work, but I always allow my creativity to flow freely. I took several artistic liberties with this project so that my final artwork was more compelling than my photo reference.

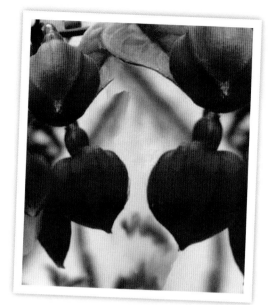

Color Palette

Oil Colors: crimson • phthalo red rose • phthalo violet
quinacridone rose • sap green
titanium white • yellow green

Oil Pastels: kelly green • red rose • violet or purple

Medium: one part liquin + one part turpentine

Artist's Tip

Understanding the rules of color, including value, temperature, and complements, is an important part of painting flowers and floral scenes. Before starting any project, review "Color Theory" on pages 10–11.

Step 1 I begin by mixing one part liquin and one part turpentine in a glass jar, and set aside a small amount in another lidded jar to use later. This is known as a "medium mixture." To tone the canvas, I mix a quarter-size dollop of the medium mixture with an equal size dollop of sap green using a palette knife or large flat brush until I have a transparent hue. (It may be necessary to keep adding medium until the paint becomes transparent.) Then I apply the mixture to the entire canvas in loose, quick strokes, emphasizing the areas of foliage.

Step 2 Next I mix a small dollop of medium with phthalo red rose until I have a transparent hue. I continue the underpainting by applying the mixture with a broad flat brush and loose strokes across the areas of the canvas that will be the fuchsia blossoms. To lighten areas of paint, I brush on clear liquin using a broad flat brush. The underpainting creates a wet surface for the steps that follow.

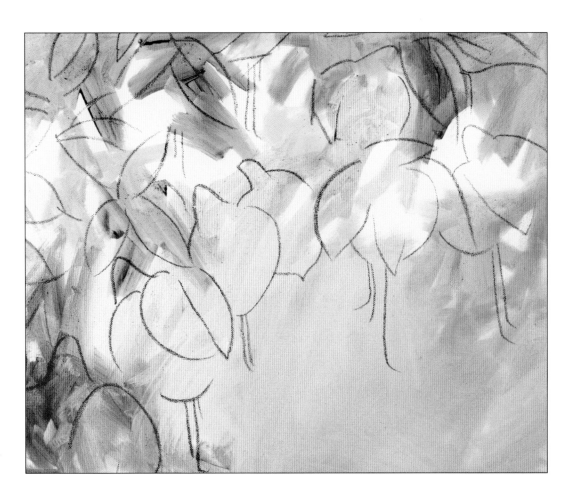

Step 3 Using the kelly green oil pastel I draw the outlines of the leaves in thin, continuous lines. I do the same using the red rose oil pastel or phthalo red rose paint for the fuchsia blossoms. Making mistakes isn't a problem—they can easily be fixed because I'm working on a wet surface.

Step 4 Now I place one dab each of sap green, yellow green, and titanium white on my palette. I load a small flat brush with my medium mixture from Step 1 and a bit of sap green to begin painting in the leaves. Then I follow this same process with the yellow green and titanium white, always working from darkest to lightest.

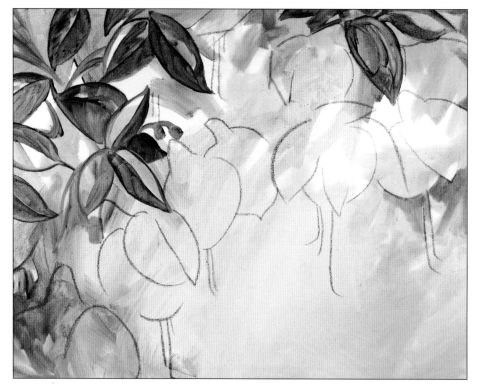

Artist's Tip

Using less medium mixture when applying the oil paints will create a thicker, more opaque layer in areas where you want more detail.

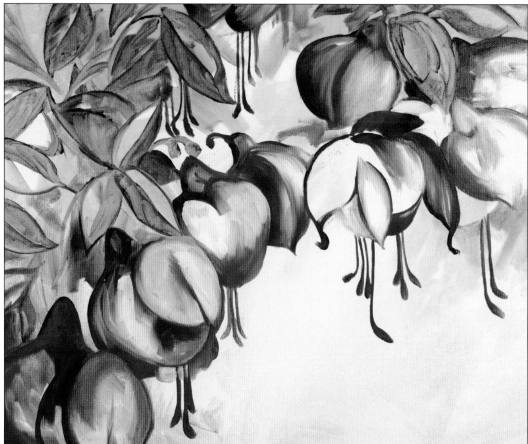

Step 5 I place one dab each of quinacridone rose, crimson, phthalo violet, and titanium white on my palette. Following the directions from Step 4, I begin filling in the fuchsia blossoms, again working from darkest to lightest. I make sure to clean my brushes each time before changing colors.

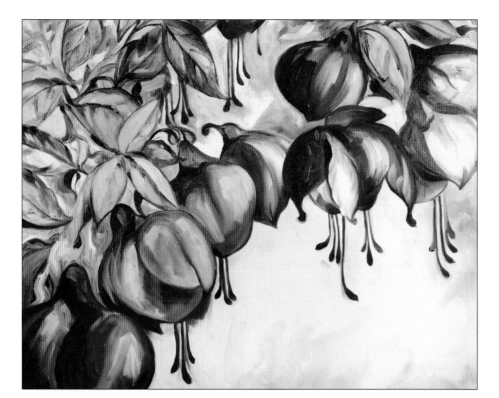

Step 6 With the primary shapes established, I begin to further define and sharpen the leaves and blossoms I want to have more detail, and blend and soften areas of less focal interest. To sharpen edges, I use the side of a soft, flat brush, loaded with paint and less medium than in previous steps. Then I use a soft flat brush to gently blend and soften edges that move away from the central focal point. Finally, I use titanium white and flat, bold strokes to add highlights where needed.

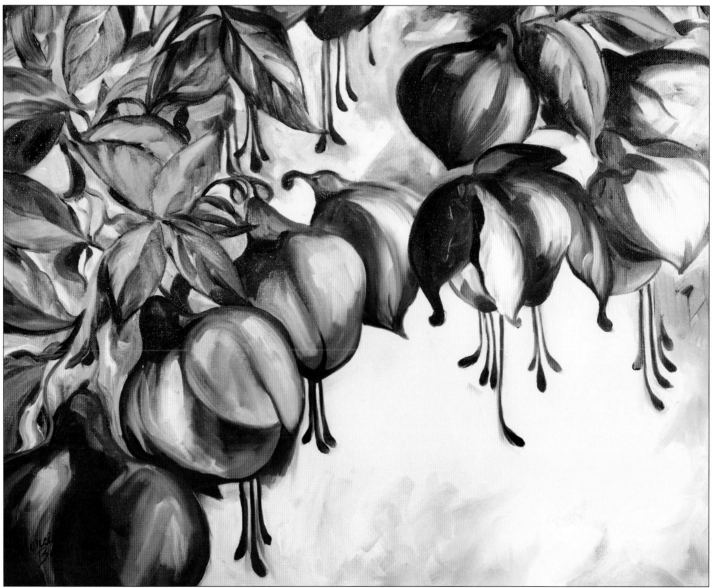

Step 7 I add a bit of titanium white to sharpen some of the blossom edges and give them a clean finish. Then I use some titanium white to soften the edges around the foliage. Finally, using a small round brush, I sign my finished piece.

Lily *with Marcia Baldwin*

I didn't have a reference photo for this project, so I started with a rough sketch of my own creation to help guide me while painting. Don't feel that your painting has to match your sketch precisely though. Let your creativity take you where it wants for the best outcome.

Color Palette

Oil Colors: cadmium barium orange • cerulean blue phthalo green earth • lemon yellow • phthalo blue red shade phthalo violet • red deep • red medium • sap green • titanium white • Winsor Newton blue • yellow deep • yellow green

Oil Pastels: deep red • kelly green • purple

Medium: one part liquin + one part turpentine

Step 1 I cover my canvas with the liquin/turpentine medium mixture that I set aside in step 1 from the last project. (See "Fuchsia," page 40.) With the canvas still wet and working from dark to light, I begin blocking in the flower with lemon yellow combined with the medium mixture, followed by yellow deep combined with the medium mixture.

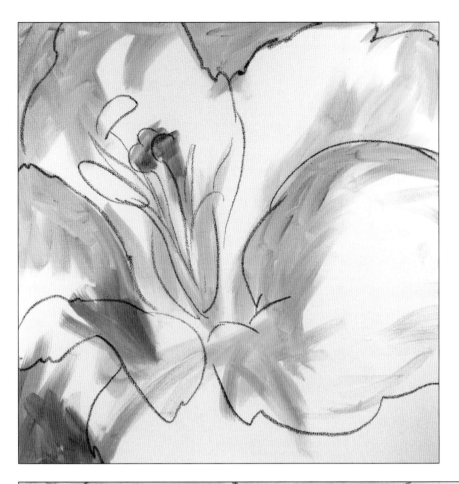

Step 2 Using the reference sketch as my guide, I lay down the petal outlines directly on the wet canvas using the deep red oil pastel. (Another option is to use the tip of a round brush dipped in red deep paint.) Next I draw in the outline of the stamens with the kelly green oil pastel. Finally, I add the tops of the stamens with the purple oil pastel. (Phthalo violet paint also works.) I keep my lines loose and free of excessive detail.

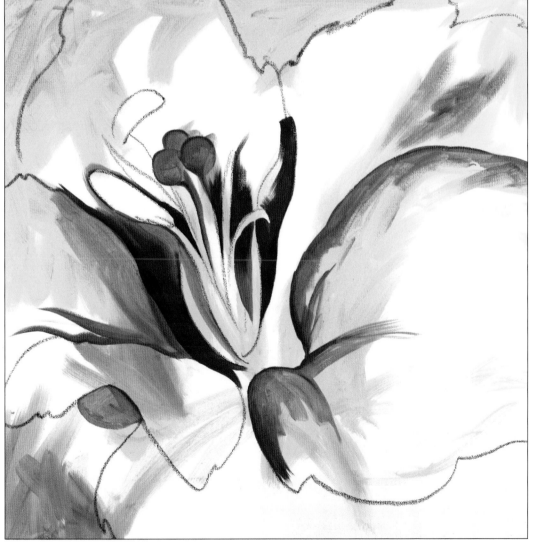

Step 3 Using a ½-inch flat brush, I begin to paint in the larger petal areas and stamens tops with the yellows, reds, and oranges from my palette. Working wet-into-wet, I lightly blend my color into the outlines I created. I allow the canvas to dry for about an hour before moving on to step 4.

Artist's Tip

To create depth in your painting, softly blend areas that are farthest away from the focal point of the composition.

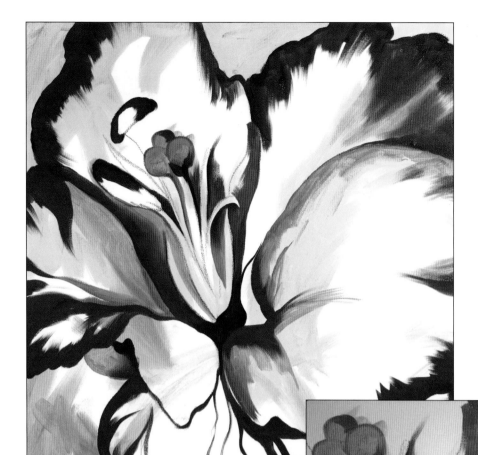

Step 4 After allowing the painting to dry for a bit, I begin adding reds to the outer petals, working from dark to light and blending each into the adjacent colors. I use a soft flat brush to create crisp, defined edges where needed. Then I soften edges that are farthest from the focal point with a clean flat, dry brush.

Step 5 I load a clean brush with my medium mixture from step 1, and then dip the brush into titanium white. Starting in the center of the petals, I drag the brush up and out, blending into the reds and oranges. I wipe the brush clean as I pick up the darker hues. Then I clean the brush with clear turpentine and pat it dry with a soft cotton cloth. I repeat this in all the lightest petal areas.

Detail

The white paint will seamlessly blend into the deeper hues with a light touch.

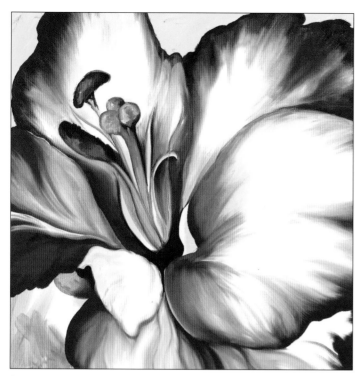 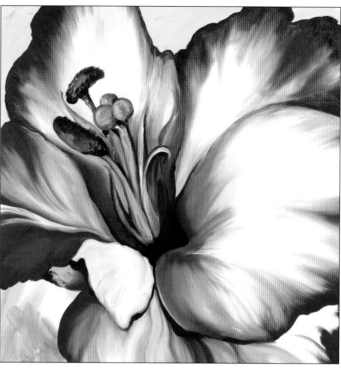

Step 6 I load a ¼-inch flat sable brush with sap green and begin to fill in the stamens. Next I lay in yellow green, green earth, and a touch of cerulean blue phthalo to my darker greens to deepen them. I keep the forms crisp to stay within my earlier guidelines. Then I blend the edges softly with a clean flat brush.

Step 7 To further emphasize the direction of the light source, which appears to be hitting the flower from the upper right side, I add deeper shades of phthalo violet, red deep, and red crimson to the outermost edges of the petals. This creates depth and dimension in the flower.

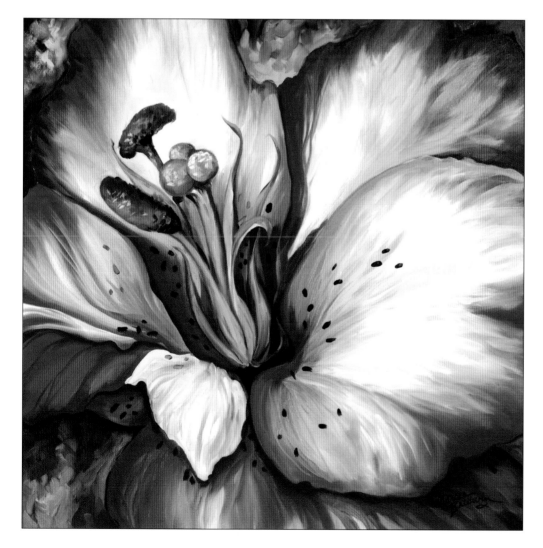

Step 8 Using a ½-inch flat brush, I loosely lay in the darker background values, including phthalo blue red shade, cerulean blue phthalo, Winsor Newton blue, green earth, sap green, and yellow green. I soften any harsh edges in the background with a clean, dry brush, taking care to protect the edges of the petals. Finally, I add various strokes of your blues and greens to the stamens, and finish by adding the dark spots to the petals.

Dahlia *with Marcia Baldwin*

Although I drew a very rough sketch of my planned composition, my underpainting, which consists of almost all of the colors in my project palette, offered me a visual color reference, which proved extremely useful as I began to layer in more and more paint.

Color Palette

Oil Colors: blue violet • cadmium orange • emerald green lemon yellow • phthalo rose red • phthalo violet • red deep red medium • titanium white • yellow ochre

Oil Pastels: rose red • violet • yellow ochre

Medium: one part liquin + one part turpentine

Step 1 I start by laying down the underpainting consisting of lemon yellow, yellow ochre, cadmium orange, and phthalo violet. I load my brush with the darkest color first, plus medium mixture. Using soft, broad brushstrokes, I apply color to the support. I continue this process, working from dark to light, making sure to clean my brush between each new color. When I have generously covered the canvas, I let it dry for about 30 minutes. Then I use a soft, dry brush to gently blend the colors into each other.

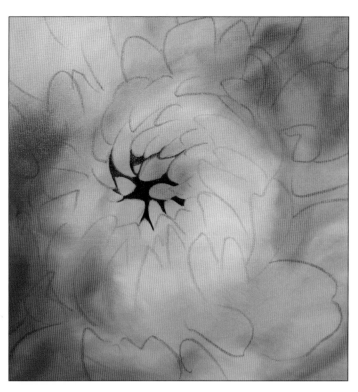

Step 2 Using quick, loose strokes, I draw the dahlia petals using an oil pastel or the tip of a round paintbrush. Then I use yellow ochre for the petal outlines that I draw over the yellow areas of the underpainting, and rose red or red deep for the outlines I draw over the reds, violets, and oranges. I keep my lines loose and free of detail, but strive to create the overall basic shape to help you form the general composition.

Step 3 Following the outlines, I begin filling in the dahlia. I use blue violet for the darkest, shaded areas. For the tips of the muted petals, I apply a mix of phthalo violet and cadmium orange.

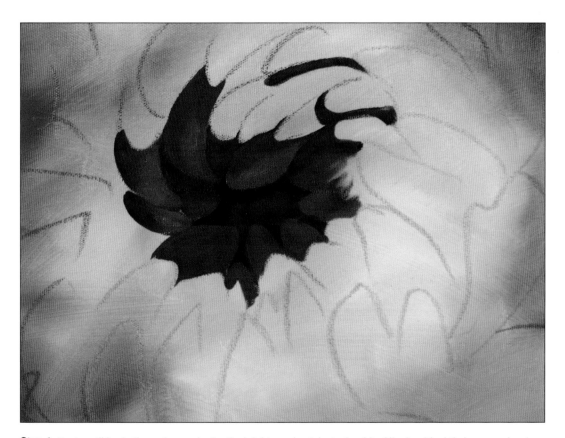

Step 4 Next, we'll lay in the various reds. For the brighter red petals, I mix a bit of liquin with phthalo rose red and apply it over the yellow underpainting. For the darker petal areas, including the shadows, I add a bit of emerald green to the red mix. I begin applying the color to the petals, making sure to stop and blend them occasionally with a flat sable brush.

Step 5 I continue layering in the reds, making sure that my brushstrokes curve with the shape of the petals. When I have finished applying the reds, I go back over and fill in the deepest shadows with the emerald green/red mixture. I use phthalo violet to add shading in areas.

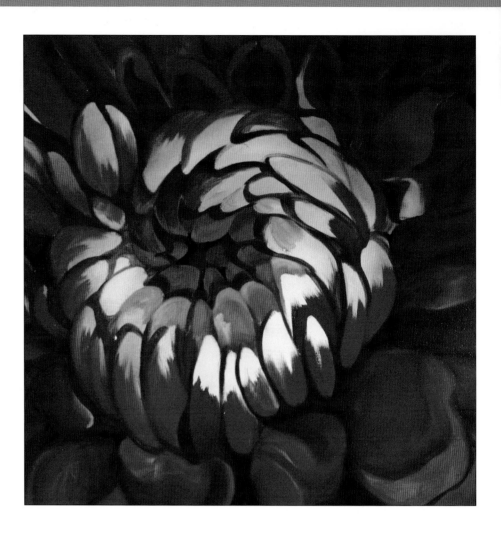

Step 6 Here I mix a dab of red rose with titanium white and then another dab of cadmium orange with titanium white. I add highlights to the petals in select areas, and softly blend the hues into the darker tones using a clean, dry brush. I enhance any shadows, edges, or darker areas with strokes of red deep or phthalo violet.

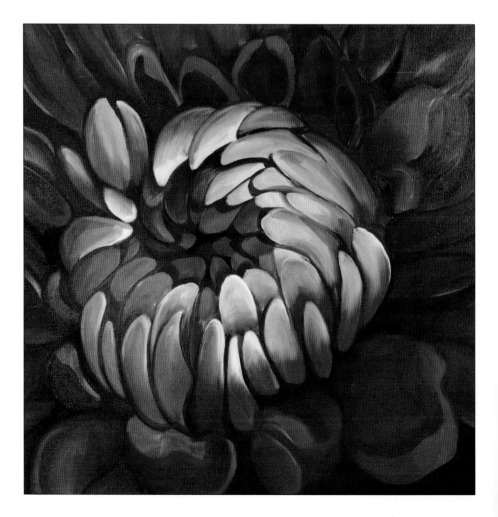

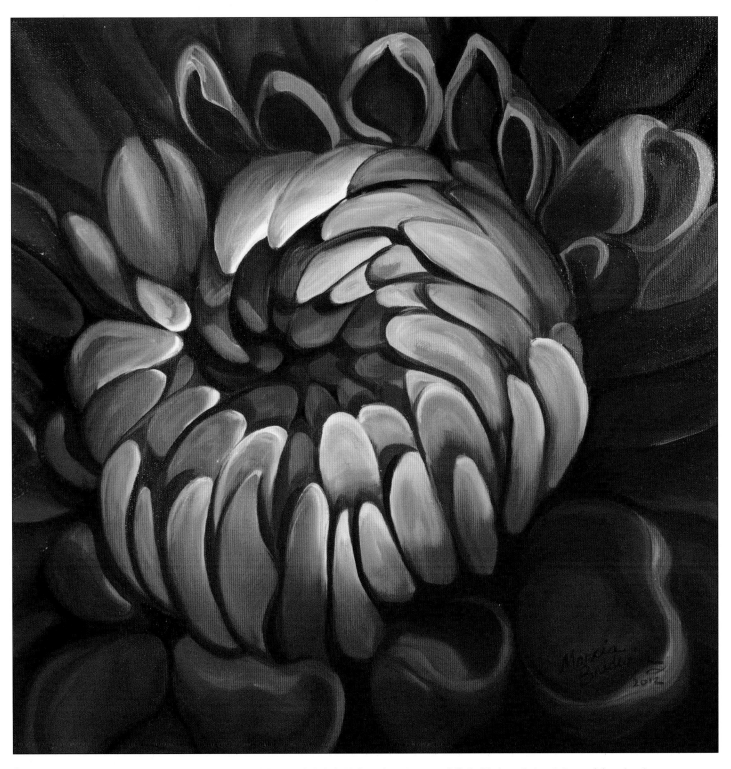

Step 7 I finish darkening the deepest shadows with red deep and phthalo violet. When I'm are satisfied with the painting, I sign and date the piece.

Orchid *with Marcia Baldwin*

My daughter, Sherry Fain, took this beautiful photograph in England. It is a classic orchid composition, but I look several liberties with color for my painting. I envisioned a close-up composition on a square canvas; then I drew several sketches before settling on one that I liked. I added more blues, reds, and oranges than are reflected in the photo, which contributed to a more abstract finished painting.

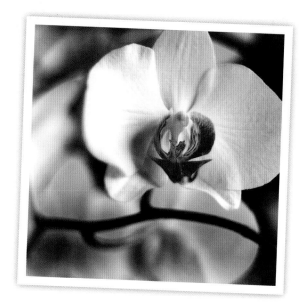

Color Palette

Oil Colors: alizarin crimson • burnt umber • cadmium barium orange • lemon yellow • manganese blue hue phthalo rose red • phthalo violet • sap green titanium white • ultramarine blue

Oil Pastels: cerulean blue, pink, violet

Medium: one part liquin + one part turpentine

Step 1 I place one dab of each of the following on my palette: ultramarine blue, manganese blue, sap green, and lemon yellow. Next I add a bit of my medium mixture to each paint dab. Using broad brushstrokes, I block in a rough outline of the orchid, applying each of the colors, working from darkest to lightest. When finished, I use a clean brush to apply the clear medium to the remaining areas of the canvas.

Step 2 Using the sketch as a guide, I lay in the outline of the composition using oil pastels. (Another method is to use the tip of a round brush dipped in paint.) I use cerulean blue for the petals and pink (violet or phthalo violet would also work) to position the center of the flower. My lines are loose and continuous.

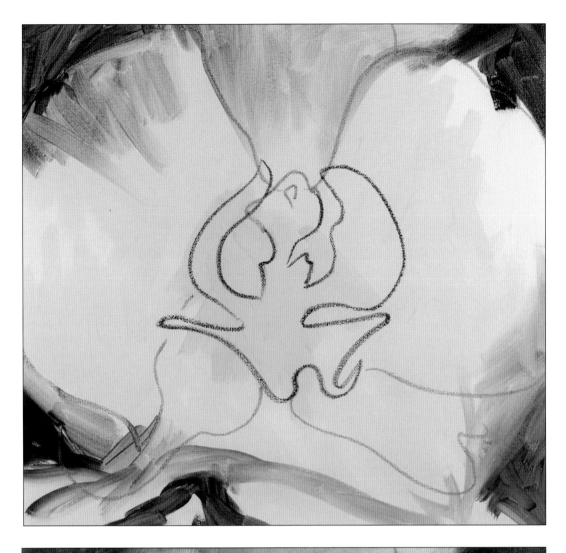

Step 3 Using a clean, dry, 1-inch flat brush, I lightly blend the entire canvas, including the outlines. I wipe my brush with a cotton rag periodically to ensure that it stays clean and dry.

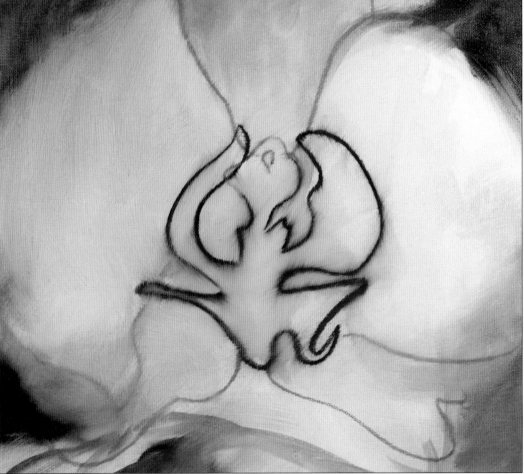

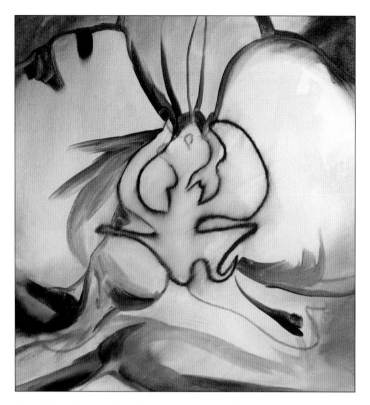

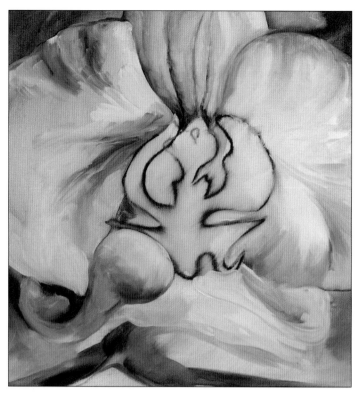

Step 4 Now I begin to layer in the cooler hues. I add the medium mixture to each of the following colors: manganese blue hue, ultramarine blue, and phthalo violet. Working from dark to light, I apply each of the colors to the shadowed areas.

Step 5 I load a ½-inch flat brush with titanium white mixed with a touch of ultramarine blue. Then I begin laying in the base petal color, paying attention to the crisp edges of the blossom. I softly blend this color into the shadowed areas I laid down in step 4.

Step 6 I add a mixture of violet and ultramarine blue to emphasize the outermost edges of the petals. Then, working from dark to light, add sap green and burnt umber to the background to give depth to the painting. I spend some time experimenting with these areas, playing with different brushes and varied brushstrokes.

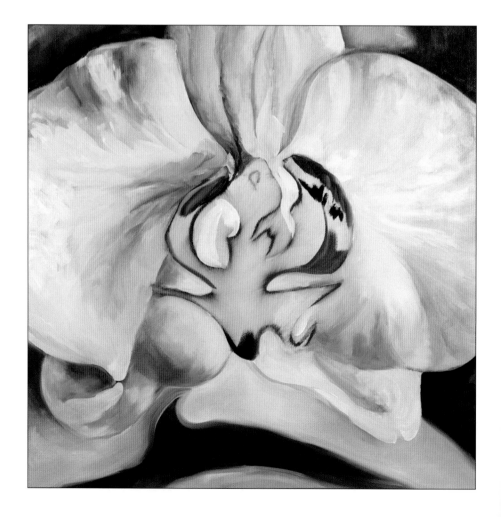

Step 7 To create the focal point—the heart of the orchid—I lay down alizarin crimson, cadmium barium orange, and phthalo violet. I keep my brushstrokes simple, blending some together with a clean, soft brush. I finish by adding the details, such as the spots on the center petals, and sharpen or blend any other areas as needed. I sign my name and enjoy my new painting.

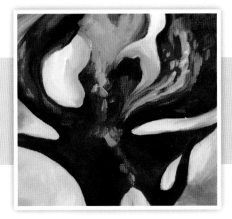

Detail

I used a dabbing motion to apply the colors to the center, which also added depth and texture.

Sunflower *with Marcia Baldwin*

The sunflower is a large blossom with bright yellow petals that appear to be translucent when the sun shines through them. The seeds in the center offer lots of texture; they range in color from rich ebony to sunny orange to white, making this flower a delightful subject to paint.

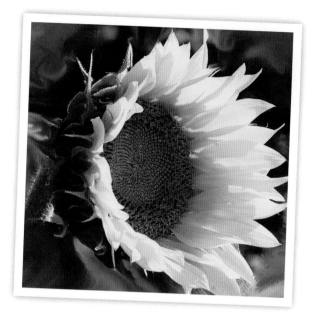

This photo hails from the Annual Sunflower Trails, a yearly event that is held near my home each July, wherein farmers cultivate sunflowers on their land along a 10-mile stretch of road in Gillam, Louisiana. The result is a breathtaking display of stunning sunflowers that inspires locals and tourists alike.

Color Palette

Oil Colors: burnt sienna • burnt umber
cadmium barium orange • deep yellow • lemon yellow
lime green • phthalo blue • sap green • titanium white
violet • yellow ochre

Medium: one part liquin + one part turpentine

Step 1 Starting with the center of the sunflower, I apply cadmium orange combined with my medium mixture using swift, bold brushstrokes. Next I apply deep yellow mixed with medium. Then I loosely brush on sap green to indicate the stem and foliage. Finally, I use a clean, dry brush to lightly blend strokes together. This will be the underpainting.

Step 2 Next, I load a ¼-inch brush with sap green and outline the leaves and foliage around the blossom. Using the same brush, I use deep yellow to paint the petal outlines, followed by burnt sienna to delineate the center.

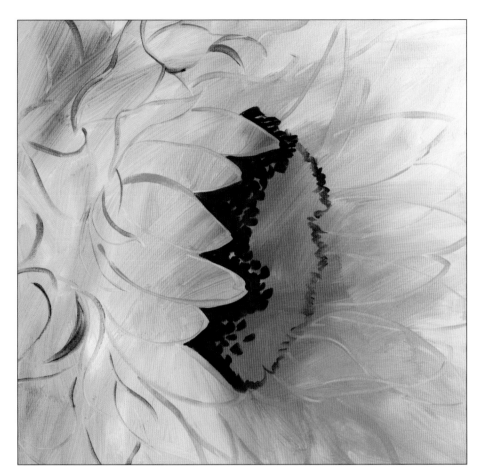

Step 3 With ½-inch flat brush with a crisp edge, I begin filling in the center with burnt umber. I use short, multidirectional strokes to create clean edges between the petals. As I move toward the center of the blossom, I allow a bit of the orange underpainting to peek through. Continuing this I begin dabbing in burnt sienna, cadmium barium orange, and yellow ochre to give the seeds depth and texture.

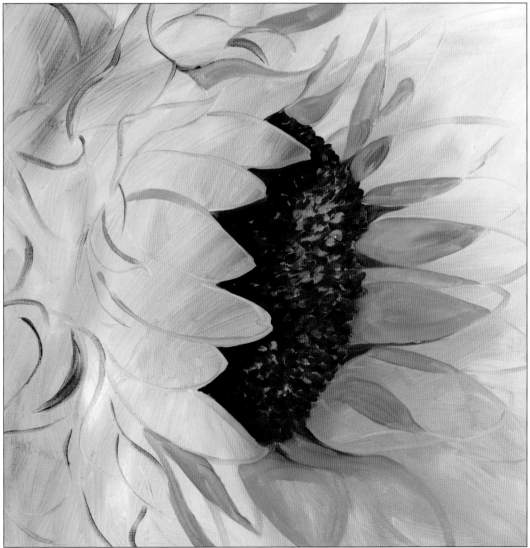

Step 4 Using a variety of brush sizes, I continue to apply heavy dabs of burnt sienna around the perimeters of the sunflower center, remembering to leave a bit of the orange underpainting showing through. Then I load a smaller brush with deep yellow and cadmium barium orange, and dab color around the protruding seeds and surrounding petals.

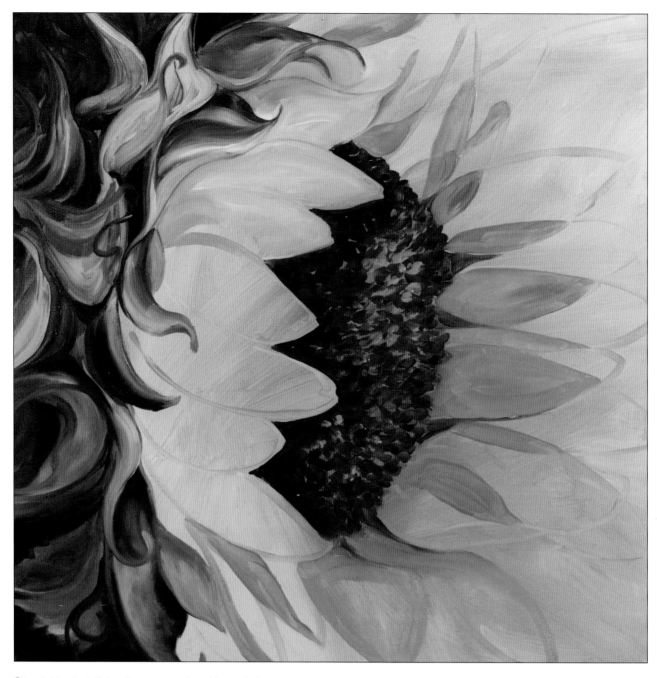

Step 5 I begin defining the green petals and leaves by layering in sap green, phthalo blue, lime green, and burnt umber—always working dark to light. I work wet-into-wet until I'm happy with the color; then I add highlights with a clean brush dipped in titanium white.

Artist's Tip

When a highlight appears too bright or out of place, use a soft, one-inch sable or synthetic flat brush to softly blend the white into the adjacent hues.

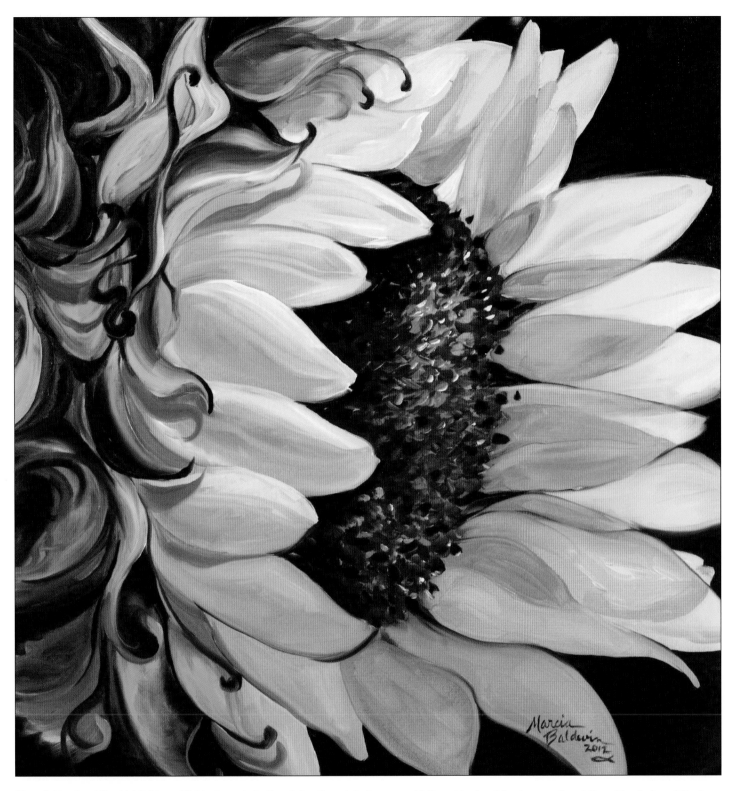

Step 6 I begin adding highlights and lighter tones to further define the petals, leaves, and foliage. I begin adding lemon yellow, followed by strokes of titanium white, for the petals in the foreground. Then I lightly blend all remaining colors on the petals. I add strokes of violet, phthalo blue, and lime green to the green foliage to create added depth, and use the sharp edge of the flat brush to define the edges of the petals and leaves. Finally, I apply violet, burnt umber, phthalo blue, and crimson to fill in the dark background. A clean, dry brush helps soften the contrast between the petals and background.

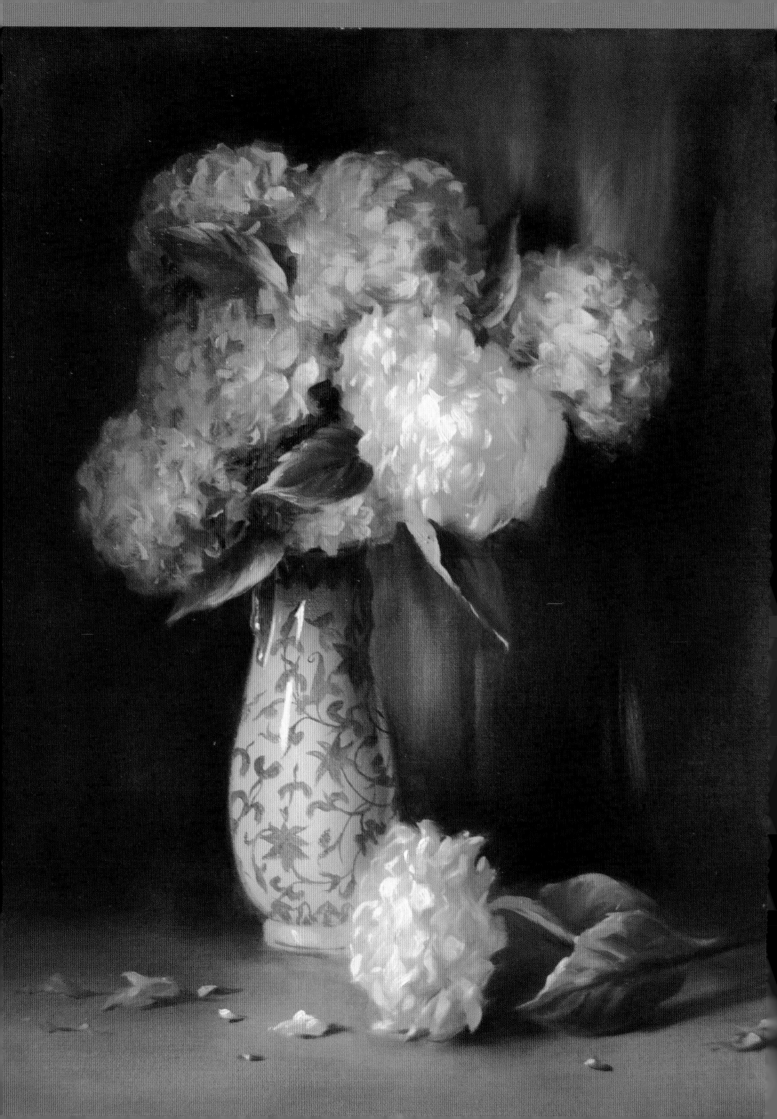

Floral Still Lifes

with James Sulkowski and Varvara Harmon

Daisies, roses, a single magnolia blossom. Because we're so familiar with their simplistic beauty, these flowers may at first seem an unchallenging subject to paint. But when altered even by the subtlest hints of light and shadow, these everyday arrangements take on an entirely new form. Although capturing the flowers' essence remains key, the lessons that follow urge you to produce more than just a copy of the still lifes featured. Be inspired by their lost and found edges. See new shapes as the light shifts. And play with warm and cool tones until you achieve visual harmony.

Peonies *with James Sulkowski*

As you approach this painting of delicate peonies in a porcelain vase, consider this important axiom: warm light, cool halftone, warm shadow. There is a perfect balance of warms and cools in nature. This is best observed when painting under natural lighting conditions; it isn't as apparent when using artificial light.

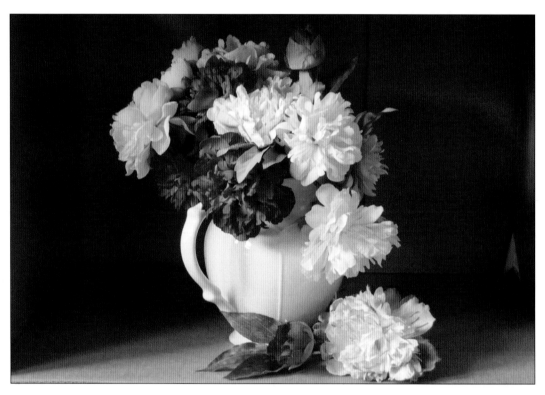

Step 1 I begin by setting up my floral still life in a box to control the light on my subject. The lightest peonies (white) are placed to the right of the composition with the light source coming from the left. The pink and red peonies are arranged in a progression, away from the white peonies. Notice how the pink and red peonies recede in color and move into the shadow.

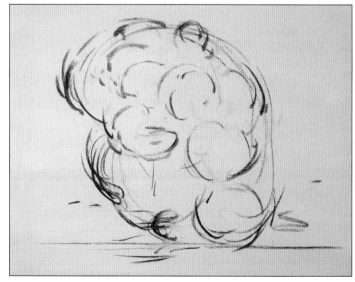

Step 2 Next I tone a 16" x 20" canvas with thinned cadmium red medium. Then I sketch my subject in soft vine charcoal, noting the rhythms of my composition.

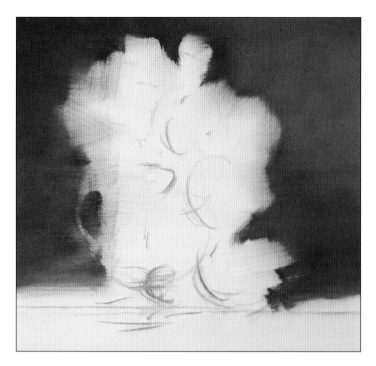

Step 3 Using a #2 white bristle brush, I "fix" my charcoal drawing by going over it with raw umber thinned with my oil medium. Then I brush off the charcoal with a 1-inch soft bristle brush. Next I paint the background with a mixture of burnt sienna and phthalo green. A 2-inch brush is ideal for painting backgrounds.

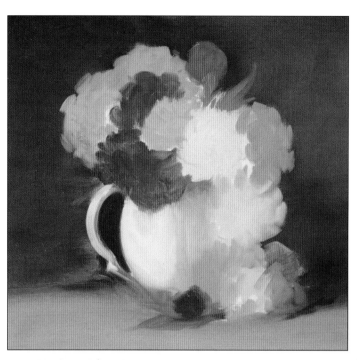

Step 4 I block in my local colors with flat middle values. For my white peony, I mix ivory, black, and white to make gray. For the pink peonies, I use a mixture of alizarin crimson and gray. And for the red peonies, I use cadmium red medium. I also add magenta to the alizarin crimson in the foreground flower. The vase is simply gray and the table is blocked in with yellow ochre.

Step 5 In this step, I begin to add darker values (the shadows on the flowers), keeping in mind the shapes I am painting and the texture of the petals. I use a darker-value gray for the white peony. For the pink peony, I use a darker pink made with alizarin crimson and a darker gray. The dark red is a mixture of alizarin crimson and cadmium red medium. Notice how the form of the objects is starting to develop.

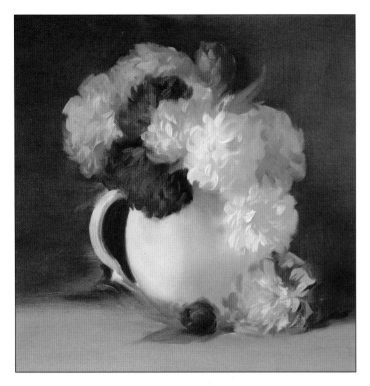 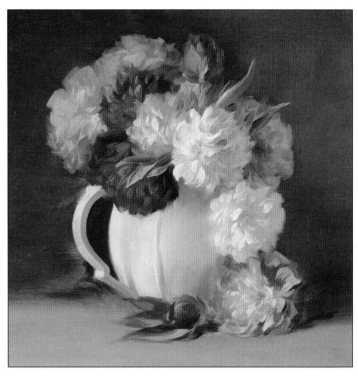

Step 6 Next I build the light in the painting, beginning with my lightest light, the white peony on the right of the bouquet in the composition. I use a #6 sable brush loaded with titanium white and a tiny bit of cadmium lemon yellow to "draw" each petal as it relates to the larger spherical form. Moving away from the white flower, I treat the pinks and reds in the same way. I use pure cadmium red light for the lights on the red peonies. By the end of this step, I have created three values or planes per object: light, middle, and dark.

Step 7 To further develop and sharpen my forms, I intensify some darks in the shadow areas. Then I develop the leaves, defining them with a #6 sable brush. I also develop the form of the vase.

Step 8 I add more leaves to emphasize the movement and rhythm of the floral composition.

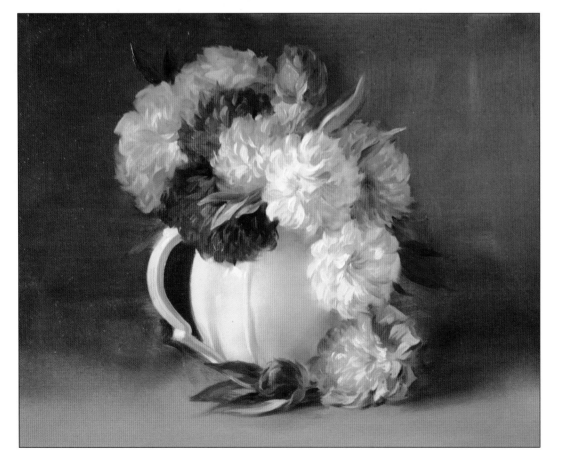

Artist's Tip

A simple mixture for the green leaves is lemon yellow, ivory black, and ultramarine blue. For a lighter green, add more yellow and white.

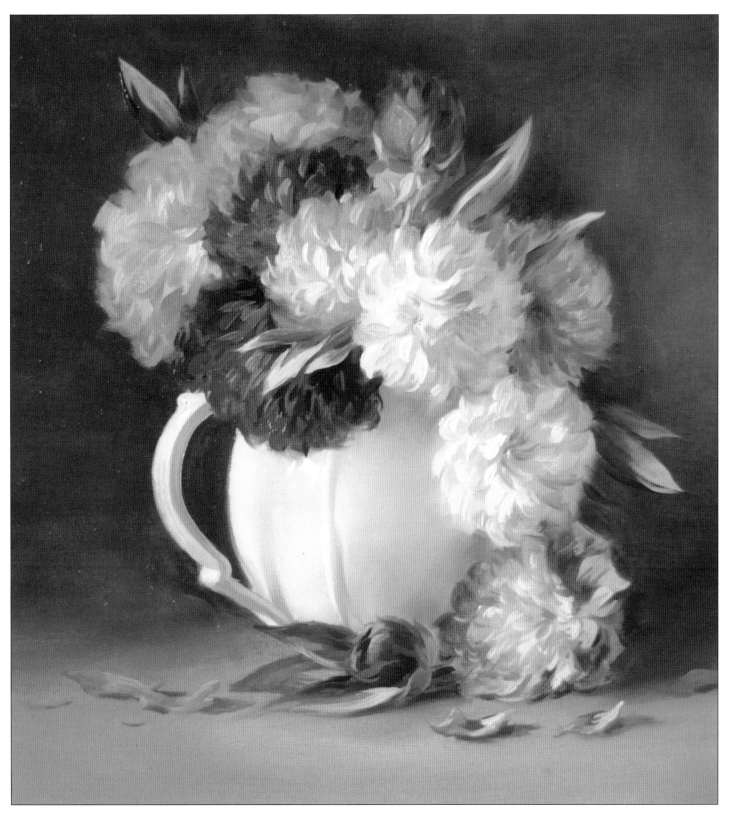

Step 9 At this stage, whatever I do, I do for the "sake of the painting." First, I decide to add fallen petals to the table. Then I darken the table on the left with a mixture of yellow ochre and raw umber to increase my light effect, or focus of the painting. I continue refining the flower petals with a #2 sable brush. I also add gray halftones on the table to create an atmospheric transition from the warm light into the warm shadow. Finally, I add a pure white highlight on the porcelain vase.

Roses *with James Sulkowski*

Painting an exquisite bouquet of roses in a vase requires an understanding of shape, lost and found edges, and how to choose the best light effect for your subject. Don't simply copy what you see; use it as inspiration. Study the movement of light and how edges disappear and reappear. The goal of this project is to create a feeling of space and atmosphere.

Color Palette

titanium white • cadmium lemon yellow • cadmium yellow light • cadmium orange • yellow ochre • cadmium red light • cadmium red medium • alizarin crimson cobalt blue • ultramarine blue • phthalo blue • raw umber ivory black • phthalo green

Optional colors: burnt sienna • magenta

Medium: one part linseed oil + one part damar varnish + one part English distilled turpentine

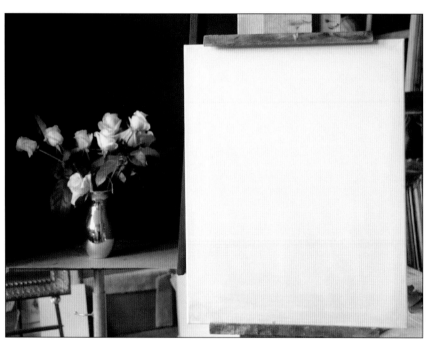

Step 1 I place my arrangement of white roses on a table in front of a black background, with the light source coming from the left. Then I tone my 16" x 20" canvas with cadmium red medium. (I either use watercolor or thin my color with turpentine.) My aim is to leave a pinkish stain on the canvas that will make the finished painting more vibrant.

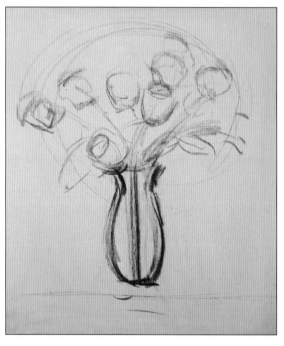

Step 2 Next I sketch with soft vine charcoal because it can be brushed off, whereas pencil and hard charcoal cannot. To avoid starting my painting too close to the edge of the canvas, I draw a light horizontal line about two inches from the bottom and begin my composition above the line. For the vase, I draw a vertical line in the middle and develop the shape symmetrically on each side.

Artist's Tip

I check the proportion of my vase with calipers to make sure the distance is the same on each side of my centerline.

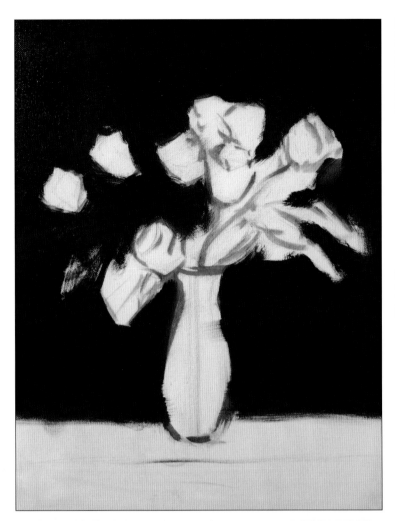

Step 3 I "fix" my drawing by applying raw umber thinned with oil medium using a #2 bristle brush. Then I brush off the charcoal with a large, soft 1-inch brush. Next I paint my background with a mixture of ivory black and cadmium red medium.

Step 4 Now I use a flat color mixture of gray (ivory black and white) and a touch of lemon yellow to block in the roses. I like to block in all areas of the painting with their local color as a flat middle tone and then build my lights and darks later.

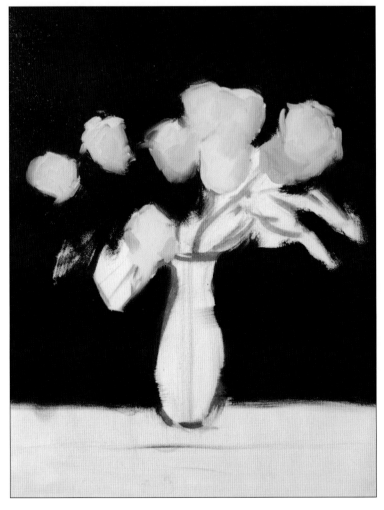

Step 5 Next I mass in the flat local colors of the leaves, vase, and table—all in their middle tones. The leaves are a mixture of gray and lemon yellow. (Ivory black and lemon yellow also make a nice green for leaves.) The table is yellow ochre in the light and raw umber in the dark, and the vase has a middle tone mixture of gray and yellow ochre.

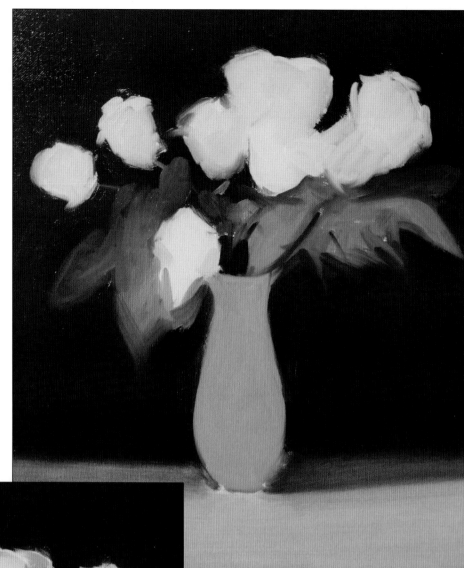

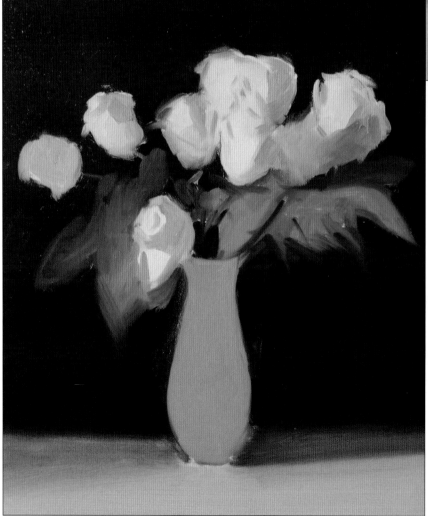

Step 6 To give the flowers shape I begin adding shadows, or darks, to each rose using a mixture of gray and a tiny bit of lemon yellow. Always pay close attention to the direction of your light source when developing form.

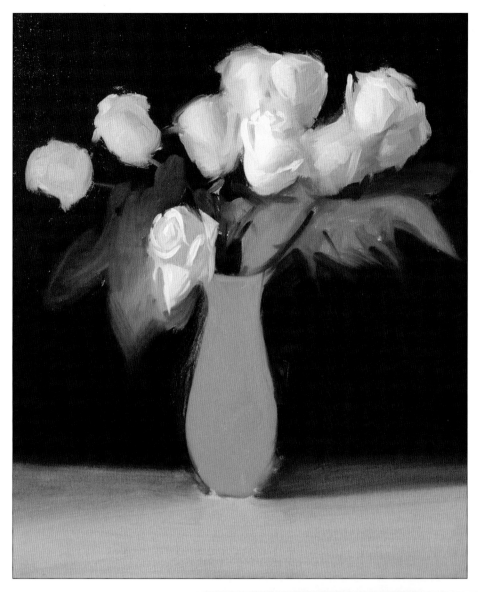

Step 7 Now I build my lightest light or what I call "the light effect"—the primary interest in the painting. Using a #2 bristle brush loaded with titanium white, I develop the most illuminated roses on the right side of the composition. Notice how the egg-shaped roses merge into each other, creating lost and found edges.

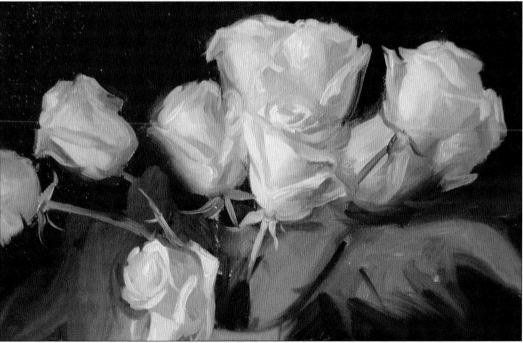

Step 8 To refine the character of the roses I draw petals around the egg-shaped forms with a #6 round sable brush. I envision the rose petals unfolding in a spiral as I follow the flower's form.

69

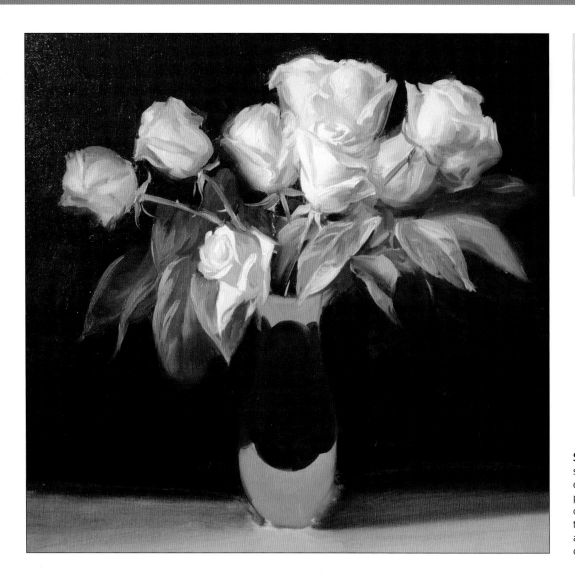

Artist's Tip
Painting silver convincingly is all about getting the darks dark enough and the highlights light enough.

Step 9 I mass in the dark of the silver vase with a mixture of alizarin crimson and ultramarine blue. When painting silver or other metallic objects, it's important to note how the edges of such masses are crisp and sharp. Next I develop the light on the leaves with gray highlights.

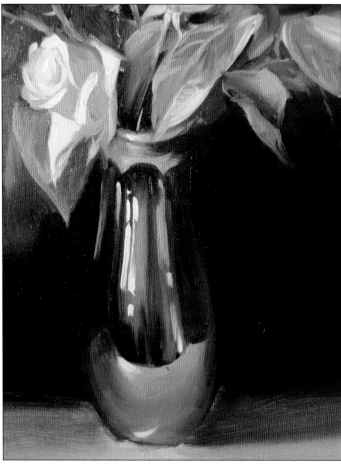

Step 10 Now I finish the vase by observing and painting the lights with lighter gray mixtures of ivory black and white, and then adding pure white highlights. My #6 sable round brush is loaded with paint at this stage. The brushwork should be fresh and clean, not overworked.

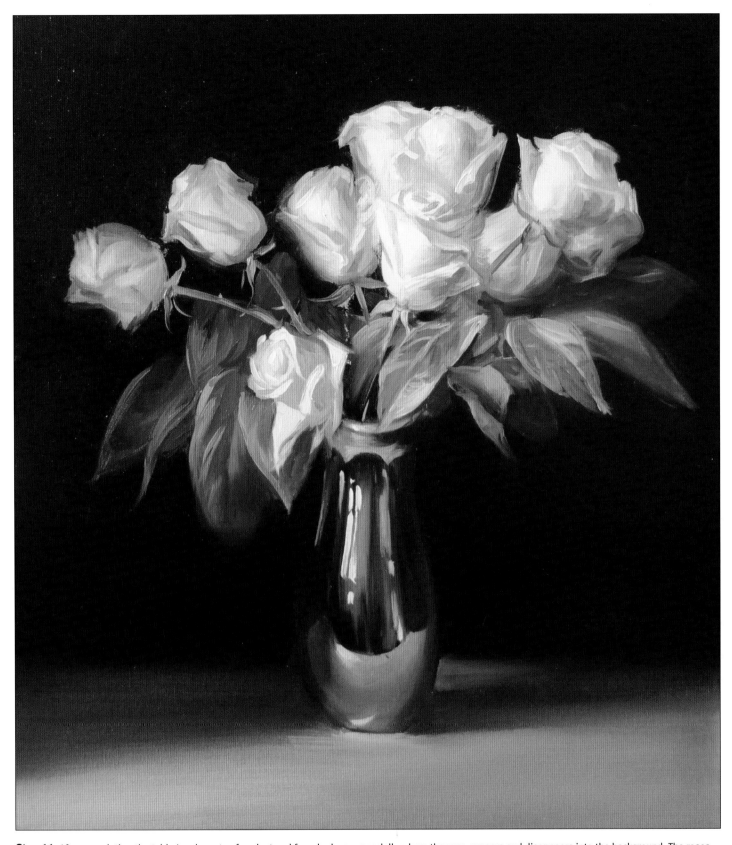

Step 11 After completing the table I make note of my lost and found edges, especially where the vase appears and disappears into the background. The roses on the left of the canvas are cooler and darker as they recede into the shadows.

Artist's Tip

Remember that values and colors are cooler and darker
as we move away from the light and warmer and brighter
as we move toward the light.

Daisies *with James Sulkowski*

Of all the floral still lifes, daisies are some of the easiest to analyze and paint. I like to reduce the form to a cup shape, which becomes especially pronounced with a single light source coming from the left. In this project, you'll learn more about light, as well as design, color, and values.

Color Palette

titanium white • cadmium lemon yellow • cadmium yellow light • cadmium orange • yellow ochre • cadmium red light • cadmium red medium • alizarin crimson cobalt blue • ultramarine blue • phthalo blue • raw umber ivory black • phthalo green

Optional colors: burnt sienna • magenta

Medium: one part linseed oil + one part damar varnish + one part English distilled turpentine

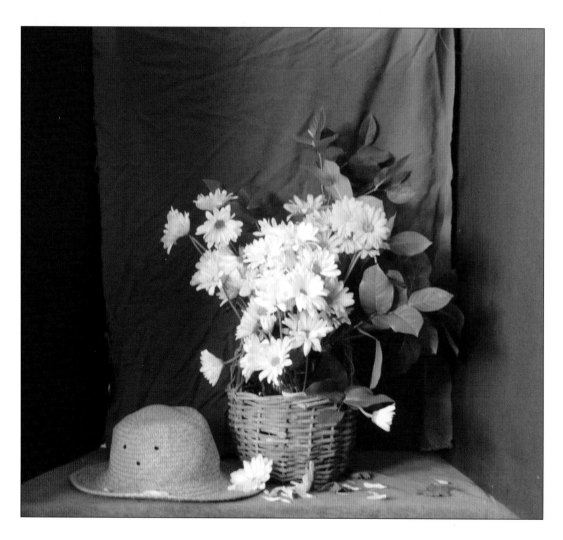

Step 1 I begin by arranging my subject on a table with a black trifold background draped with a soft, cool green material to make the background recede. My light source comes from the left, or north. Painting by cool, natural light reveals the true colors of the subject.

Artist's Tip

A light source coming from the left will illuminate the right side of the subject, creating the light effect, or focus, of the painting.

Step 2 I tone my canvas with cadmium red medium or terra rosa mixed with turpentine to eliminate the bright white. This also helps me better recognize value and color. Then I sketch my composition, standing about four to five feet away.

Step 3 Using soft vine charcoal, I keep my drawing very loose as I decide on the placement of objects.

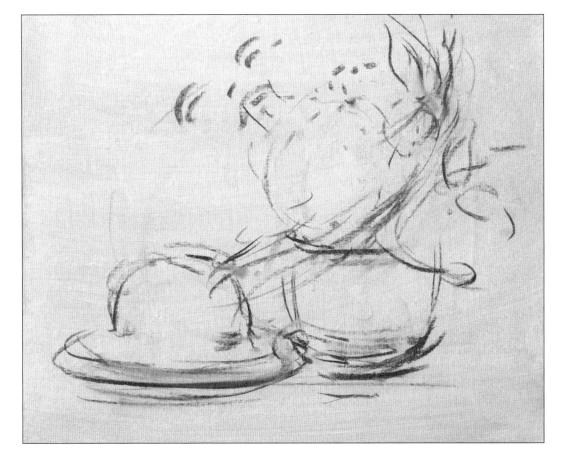

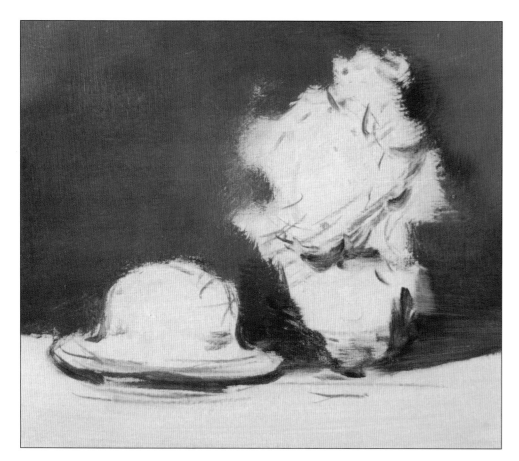

Step 4 Before painting, I study how the progression of light in the background moves from dark to light, left to right. There is also a vertical progression of light on the right side that moves from light to dark. Both are determined by the light source coming from the left. Next I mix phthalo green and ivory black for the darks. For the light I mix phthalo green with a touch of cadmium lemon yellow and titanium white. The shadows on the table are a warm mixture of raw umber and cadmium red light.

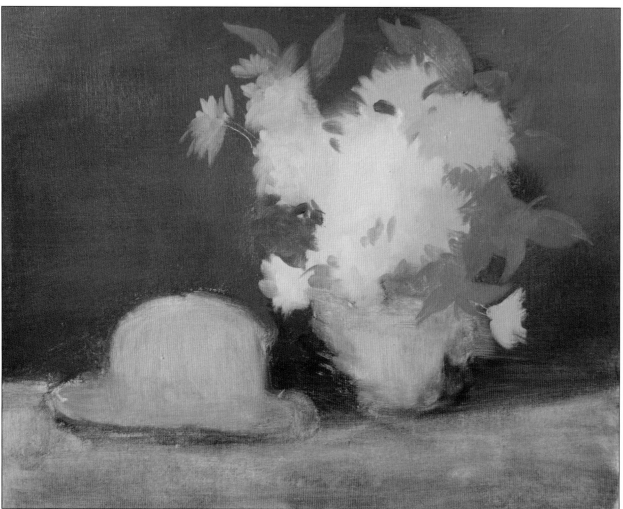

Step 5 Here I block in the entire painting with each object's middle tone. Think in terms of large masses or shapes. For the white daisies I use a light gray mixture of ivory black and titanium white. Next I use cadmium yellow light and gray for the yellow daisies. And for the violet daisies I mix ultramarine blue with alizarin crimson and white. The basket and straw hat are yellow ochre; the table is English red.

Step 6 Now that everything on the canvas is covered, I build my light effect. The light effect isn't merely a "bright spot" in the painting; it is the relationship of light to the concepts of space and atmosphere, lost and found edges, and progressions of values. I load my brush with pure titanium white to begin building the light on the white daisies that are in the brightest light. Then I use titanium white mixed with cadmium lemon yellow to build the light on the yellow daisies. All other values in the painting will relate to these brightest lights.

Artist's Tip

Starting with the background when painting a floral or still life sets the stage for the rest of the painting in the sense that all the other values and colors will relate to it.

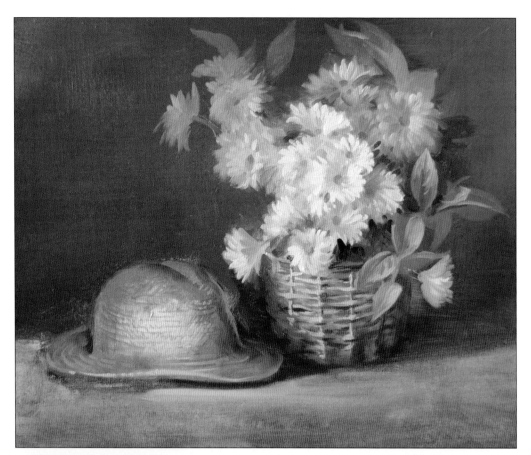

Step 7 I increase the character and forms of the flowers by adding darks. (Our three values are middle, lights, and darks.) Next I refine the textures of the basket and straw hat with lights and darks, imagining that I'm weaving with each brushstroke. I use yellow ochre mixed with white for the lights and raw umber mixed with cadmium red light for the rich, warm darks in the shadows. Middle tones are a combination of yellow ochre and a middle-value gray. Lastly, I intensify the light on the leaves with a mixture of cadmium lemon yellow, cobalt blue, and white.

Step 8 Notice how the centers of the flowers show direction. The reflected light in the flowers (made from a mixture of yellow ochre and gray) further strengthens the shape and form. Keep in mind the five planes of light: light, halftone, shadow, reflected light, and highlight.

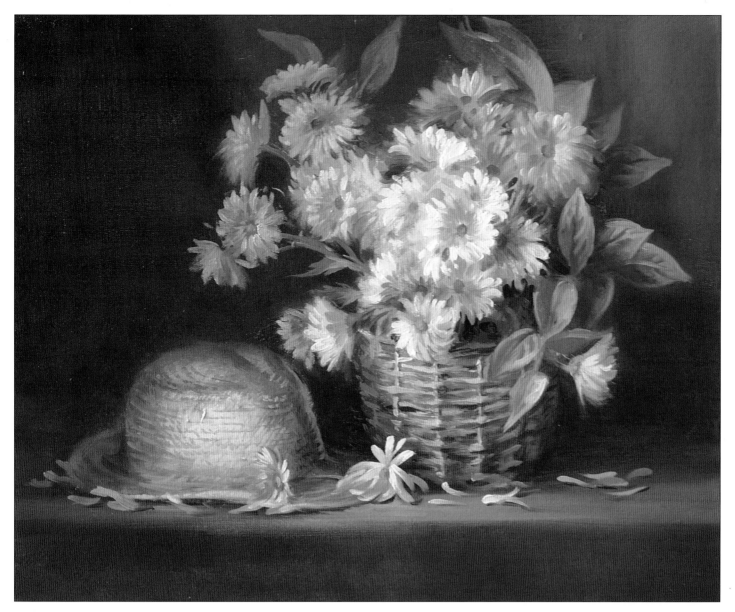

Step 9 Before finalizing the painting I decide to add more light to the upper right background. I also increase my darks on the table with English red and raw umber, and then put a few petals on the table to add interest to the overall painting. Notice that the white petals are in the lightest light just off center of the table plane. I use cooler, darker colors (yellows and violets) for the petals farther away from the light. After a final review, this still life is complete.

Artist's Tip

Remember that the form of a daisy can be thought of as a cup. It's important to simplify the concept to understand the essence of the form.

Hydrangeas *with James Sulkowski*

These hydrangeas, with their soft, pompom appearance and layered petals, provide the perfect opportunity to work on defining large forms, adding texture, and playing with light. To accurately capture the beauty of the single white hydrangea surrounded by a cluster of blue hydrangeas, you must consider how the two colors work together to create visual harmony.

Color Palette

titanium white • cadmium lemon yellow • cadmium yellow light • cadmium orange • yellow ochre • cadmium red light • cadmium red medium • alizarin crimson cobalt blue • ultramarine blue • phthalo blue • raw umber ivory black • phthalo green

Optional colors: burnt sienna • magenta

Medium: one part linseed oil + one part damar varnish + one part English distilled turpentine

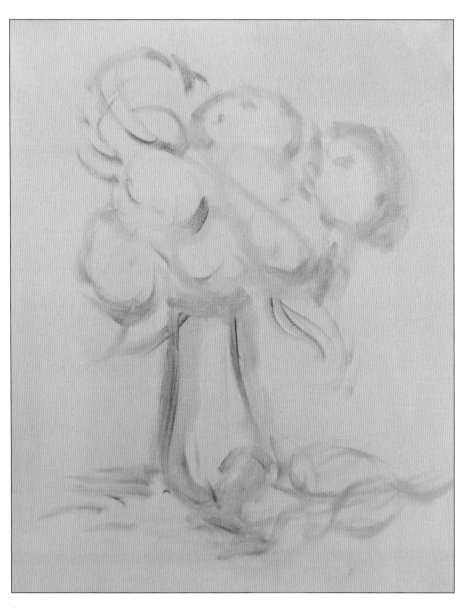

Artist's Tip

I always tone my canvas with cadmium red medium or terra rosa thinned with turpentine. The delicate pink color will come through, adding depth and luminosity to the finished painting. You can also use watercolor to tone a canvas.

Step 1 Working on a toned 16" x 20" canvas, I begin drawing with a #2 white bristle filbert brush loaded with ultramarine blue. (Note that I've thinned this blue with my painting medium.) Think in terms of the largest forms at this initial stage, keeping in mind that hydrangeas are spherical.

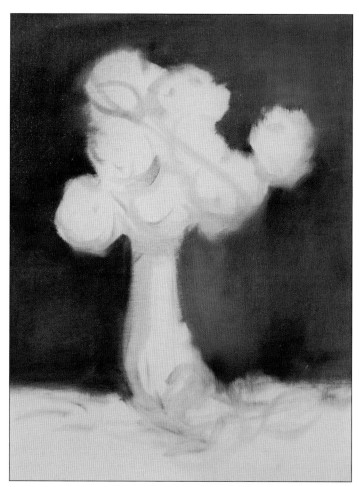

Step 2 Next I block in my background with a 2-inch white bristle flat brush. I use phthalo green and ivory black for the darker areas, and phthalo green and gray (made with ivory black and white) for the lighter areas.

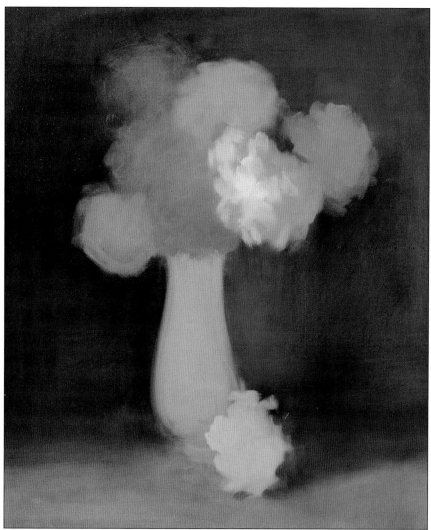

Step 3 Now I block in the middle values. I use a mixture of cerulean blue, ultramarine blue, and gray for the blue hydrangeas. Then I use gray for the vase and yellow ochre for the table. To create a convincing shadow I mix raw umber with cadmium red light. I block in the white hydrangea with light gray mixed with a touch of cadmium yellow light. The slightly darker value on the flower (the shadow) is gray and yellow ochre.

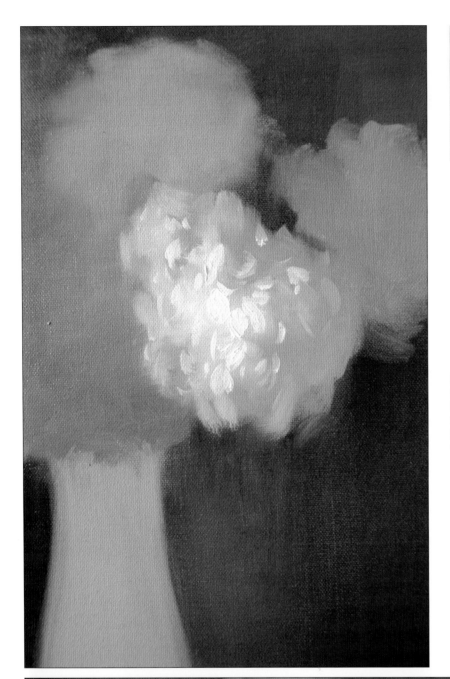

Step 4 When everything is blocked in, I begin working on the light effect. I started with a mass, or large shape, for the flower; now I must define the petals. I load a #6 sable brush with a mixture of titanium white and a touch of cadmium yellow light. Then I paint each petal individually to suggest the character of the hydrangea.

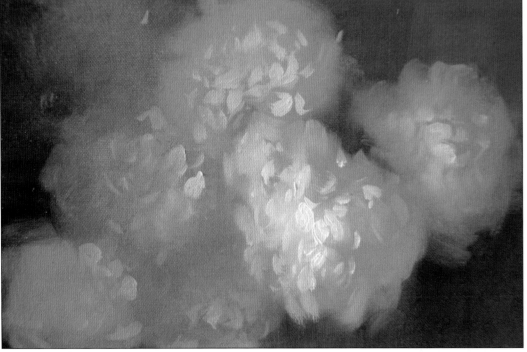

Step 5 Here I begin building the lights on the blue hydrangeas as they relate to the white one, which is the focal point of the painting. I use my #6 sable brush to pull out the petals from the mass of each flower. The lights are achieved with a mixture of cerulean blue, ultramarine blue, and titanium white.

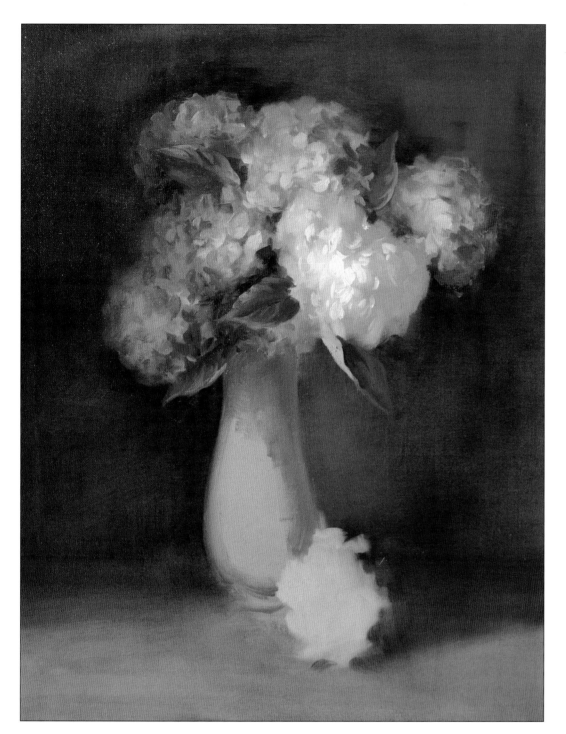

Step 6 I add the darker values to the blue hydrangeas with a mixture of ultramarine blue and gray, continuing to build the spherical shapes of each flower. Next I use a darker gray for the shadow on the vase, and then add some leaves that contribute to the rhythm of the composition.

Detail

This close-up shows the modeling of the flowers. Think of them as out of focus when you begin, and sharper, with more detail, as you develop them. Remember to start in the middle and build your lights and darks.

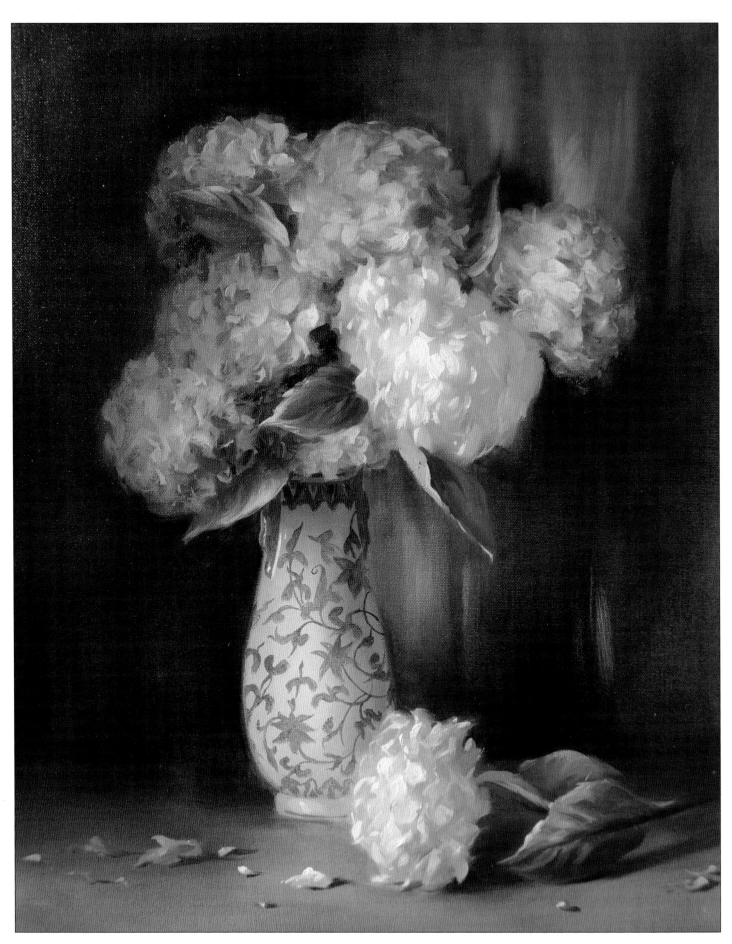

Step 7 To create more dimension, I add some reflected lights on the flowers. Then I use ultramarine blue to paint the design on the vase. For the table, I use my grays to add more half tones that create a transition between my warm light and my warm shadow. For added interest, I paint a few loose petals that have fallen on the table. Note that the white petals are in the brightest light.

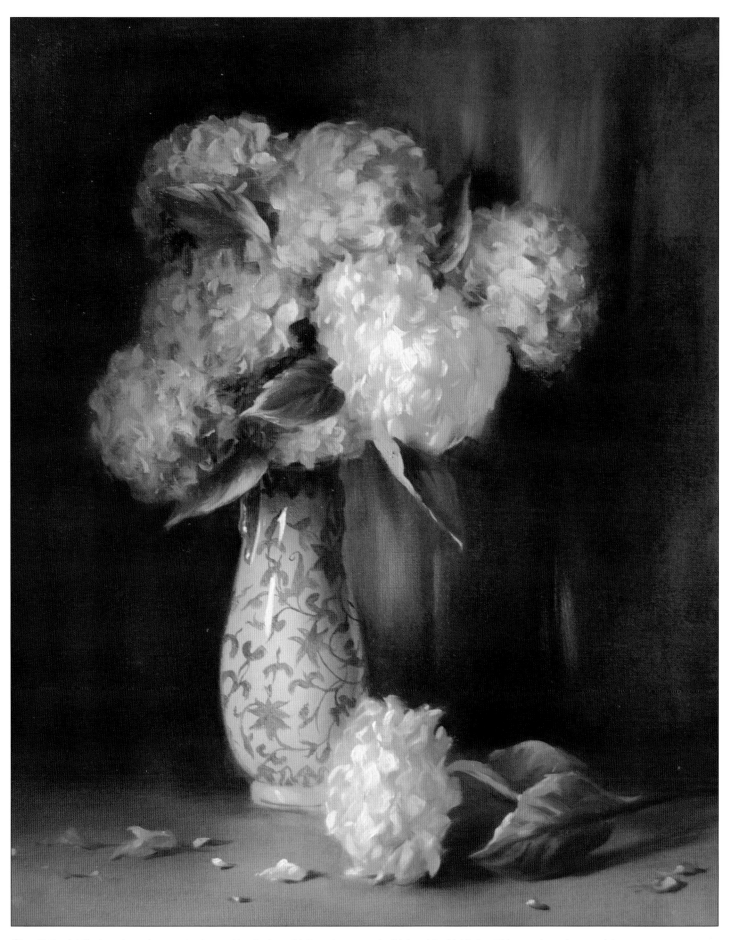

Step 8 For the final touch on the vase, I glaze a thin shadow with Payne's gray and add the white highlights. This completes the porcelain texture.

Tulips *with Varvara Harmon*

Some subjects are so complex, they beg for a simplistic backdrop. Others require a textured or colorful background to bring the painting to life. In every case, the background is as much a part of the composition as the main subject. You can use it to contrast a subject, complement it, or even unify it, as I'll demonstrate here.

<div>

Color Palette

alizarin crimson • burnt sienna • cadmium red medium
cadmium yellow medium • pine gray • sap green
titanium white • ultramarine blue • yellow ochre

</div>

Step 1 I make a quick sketch with pine gray paint on a 14" x 18" canvas. I approach my underpainting in parts, beginning with the darkest. With a ¼-inch flat brush, I paint the leaves using sap green. In the lighter areas, I add a little cadmium yellow medium to the green; in the more shaded portions, I mix in ultramarine blue instead.

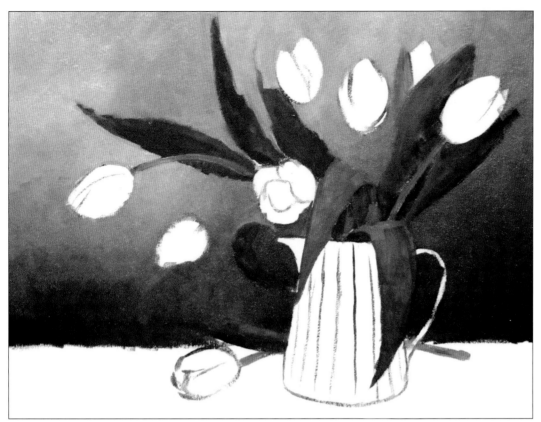

Step 2 Next I start at the top of the canvas to paint the first layer of the background. I begin with a warmer tone, mixing yellow ochre and burnt sienna, but as I move closer to the table, I eliminate the yellow ochre and gradually add ultramarine blue to the mix.

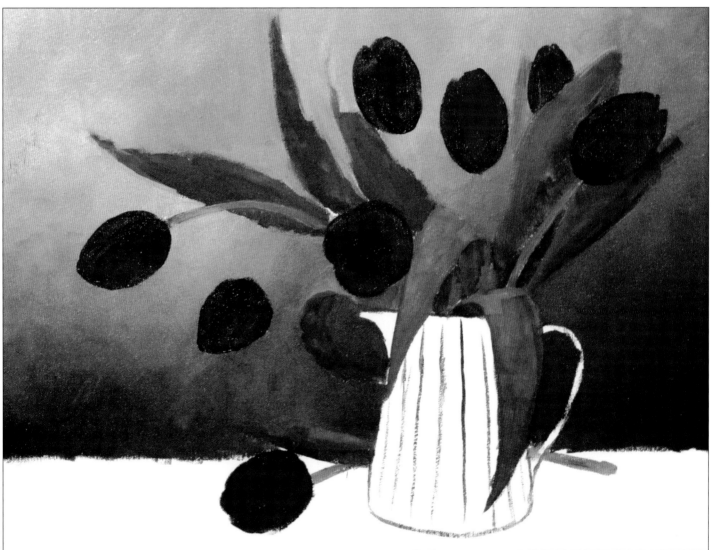

Step 3 The first layer of tulip color also varies according to shadow and highlight. For the lighter areas, I apply alizarin crimson mixed with cadmium red medium. As I move toward the shadowed areas, I add ultramarine blue for the darker tones.

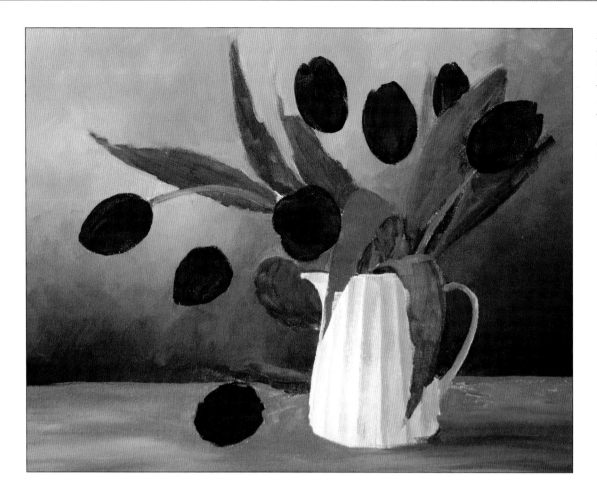

Step 4 I paint the table with a coat of yellow ochre and burnt sienna, with ultramarine blue mixed in for the shadow. The vase is mostly white, but I mix cadmium yellow medium with titanium white for the light side and alizarin crimson and ultramarine blue for the shadowed side.

Visual Blending

For the impressionistic background, I don't mix my paints on the palette. Instead, I apply separate, short strokes of color on the canvas, allowing the eye to visually blend the colors.

Step 1 Starting in the top left corner, I apply quick, short strokes of yellow ochre and titanium white, varying both the direction of the strokes and the balance of the two colors. Don't worry about covering every bit of space; the underpainting will show through any gaps.

Step 2 I continue with this method and these colors all across the top of the background, using the lighter underpainting as my map. Then, to create a reddish-brown appearance, I mix in burnt sienna brushstrokes, layering them right over the earlier strokes.

Step 3 To help smooth the visual transition that needs to occur from the light colors at the top of the wall to the darker colors at the bottom, I also layer in strokes of light purple. For these, I apply a combination of alizarin crimson, ultramarine blue, and titanium white.

Step 4 For the cooler, darker portions of the wall, I use pine gray, ultramarine blue, and titanium white, again varying the color portions, angle, and size with each stroke. Where the light-to-dark transition occurs, I touch a few darker strokes in with the lighter colors.

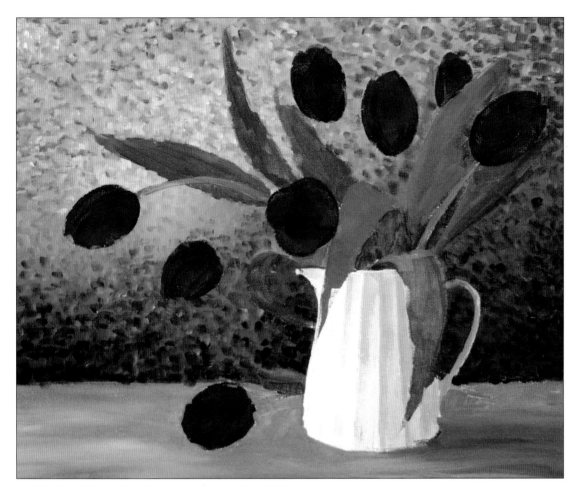

Step 5 When you've completed your background, step back to take a look. Close up, the individual strokes are very apparent. But as you step back, the eye begins to blend the colors together. The farther back you go, the greater the effect. At this stage in the painting process, you can modify the overall color by adding more strokes of any color or colors that you think might benefit the overall painting.

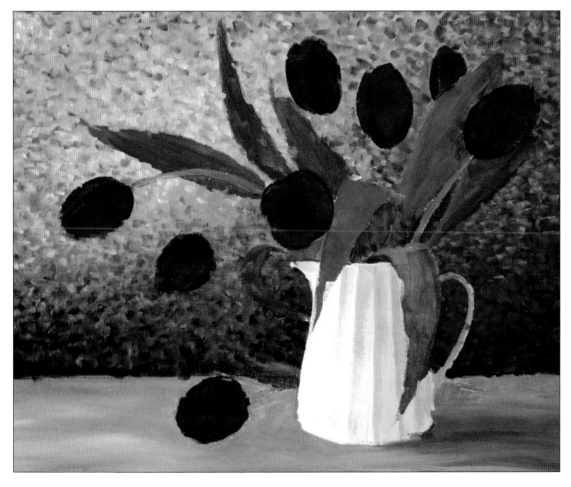

Step 6 After stepping back to observe my work, I decide the transition from light to dark is a bit sharp. To make the visual shift more natural, I stroke in more of the warm colors along the entire bottom of the wall. I also add more dark color into the transition zone.

Detail

I'm still tinkering with the background wall at this stage. This time, I decide that adding a few strokes of sap green will better reflect the tulips and unify the painting.

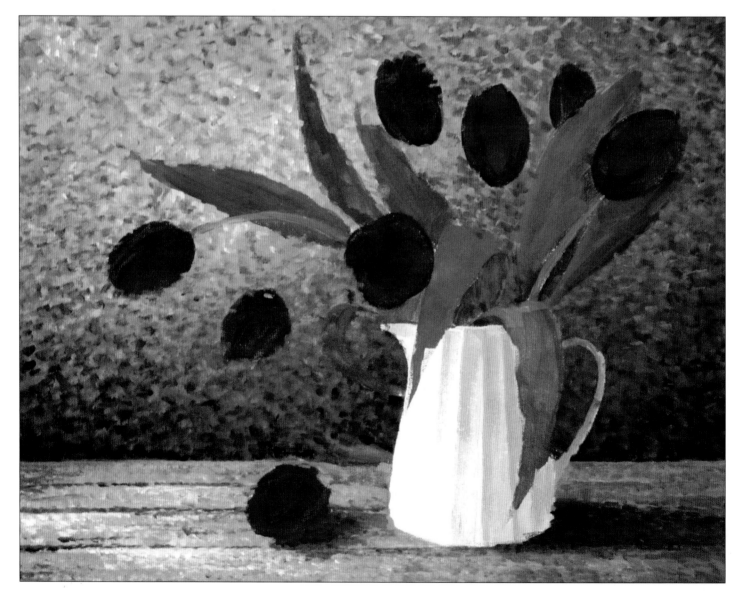

Step 7 I paint the tabletop with the same cool colors from the wall: alizarin crimson, ultramarine blue, and titanium white. I use the darker, cooler colors as well, but I apply the pine gray, ultramarine blue, and white only in the shadows cast by the tulip and vase.

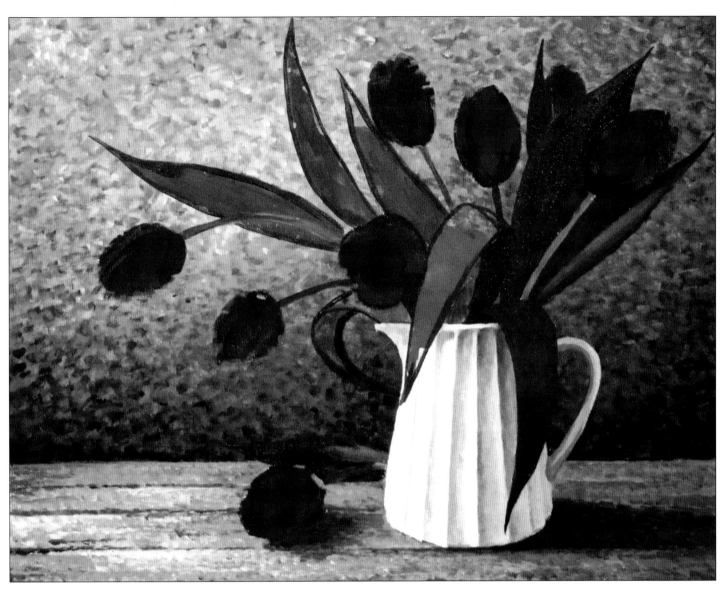

Step 8 While the sap green is still fresh on my brush, I take the opportunity to redefine the edges of the leaves. I inadvertently painted over parts of the leaves when I was quickly stroking in my background. Next I shift focus to develop the vase (see detail).

Detail

I paint the grooves of the vase using cadmium yellow medium mixed with titanium white on the light side of each groove and alizarin crimson, ultramarine blue, and burnt sienna on the shadowed side. The lighter parts also reflect a little blue from a secondary light source.

Step 9 With the edges redefined, I can paint in the shaded portions of the tulip leaves and stems. I mix sap green and ultramarine blue and fill them in with the ¼-inch flat brush.

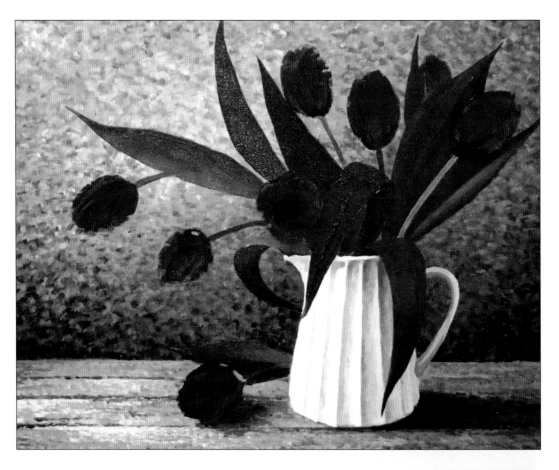

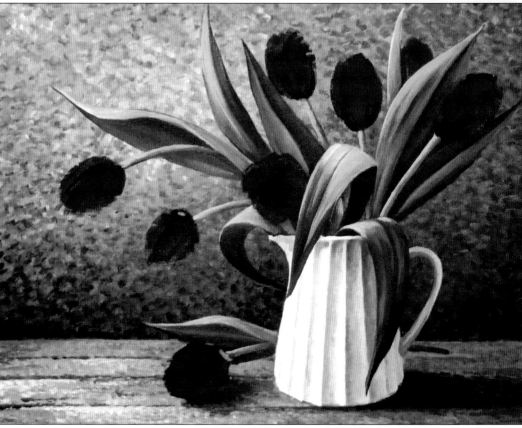

Step 10 Now I bring out more detail in the stems and leaves by adding lighter portions with a mix of cadmium yellow medium, titanium white, and sap green.

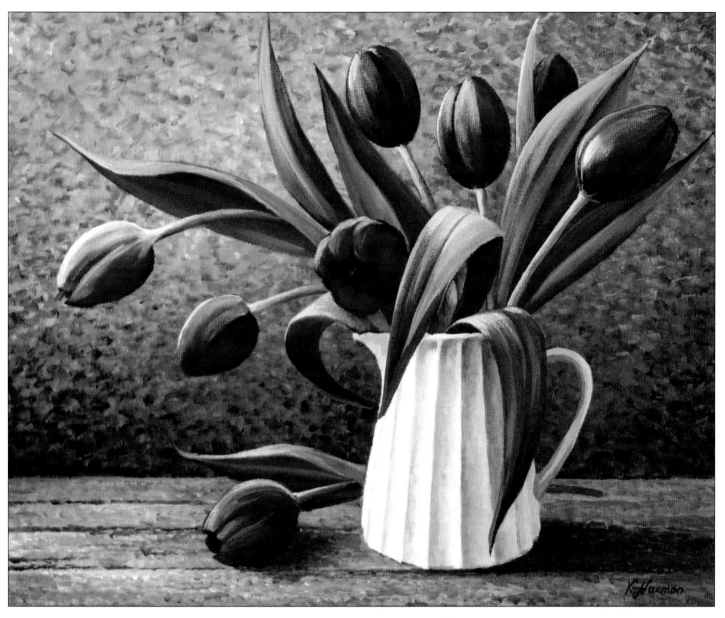

Step 11 Everything is complete now except for the flowers. I cover the underpainting with a dark layer of alizarin crimson mixed with ultramarine blue to establish the shadows. Then I apply cadmium red medium on the petals to create a transparent effect. I finish with the highlights, using a mixture of cadmium yellow medium and titanium white.

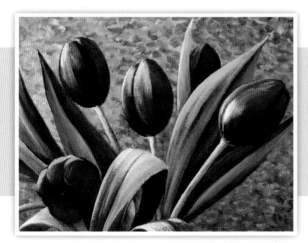

Detail

The tulips are the focal point of this painting, so attention to detail is important. Be especially mindful of the direction of the light source when applying the highlights.

Lavender *with Varvara Harmon*

Painting this charming basket of lavender will help hone your ability to create texture and dimension in a convincing way, while testing your mastery of the interplay between light and shadow.

Step 1 I begin painting the lighter portion of the background at the top of the canvas using a warm mixture of yellow ochre, burnt sienna, and titanium white. (Note: For this step, do not mix water into your paint; it should be relatively dry.) Working toward the middle of the canvas and then to the bottom, I eliminate yellow ochre and add pine gray and ultramarine blue to gradually darken these areas. Next I create the shadows of the basket and flowers at the bottom of the canvas by putting down darker and cooler colors. To create the thread in the fabric, I use the same color combinations, but with slightly darker or lighter colors. Then I brush the lines in a crisscross pattern.

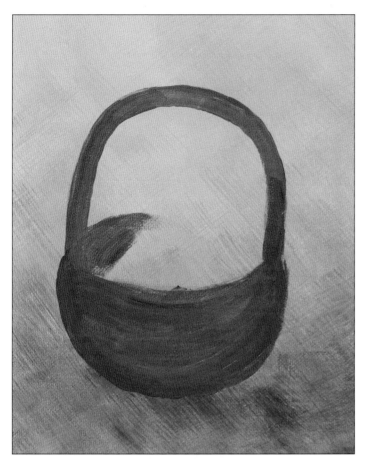

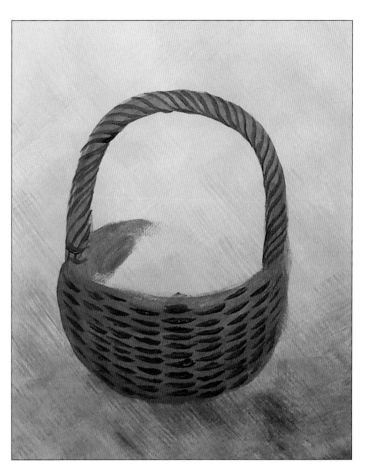

Step 2 If you don't feel comfortable painting the basket right away, pencil in a drawing first. I painted this basket shape using a ½-inch flat brush loaded with burnt sienna. The back of the basket is left unpainted because it will be completely covered with flowers.

Step 3 Using burnt umber and ultramarine blue, I add darker areas between the weaves of the basket to show the weaving direction and patterns. Notice how at this point, the basket has more shape but still appears flat.

Step 4 The center portion of the basket (closest to the viewer) has more light on it, so I use a mixture of yellow ochre and white. Working from the center outward, I gradually reduce the amount of white in the mixture and add more burnt sienna. Then I use a similar method and pattern to paint the handle, being mindful that the top of the handle is the lightest area.

Step 5 With a ½-inch brush, I paint the first layer of flowers using bold strokes of alizarin crimson and ultramarine blue. I concentrate on the shape of the bouquet as a whole and forego details for now.

Step 6 Next I bring out the detail of the lavender by adding titanium white to the alizarin crimson and ultramarine blue combination from the previous step with a small round brush. Note that the tops of the flowers are the lightest.

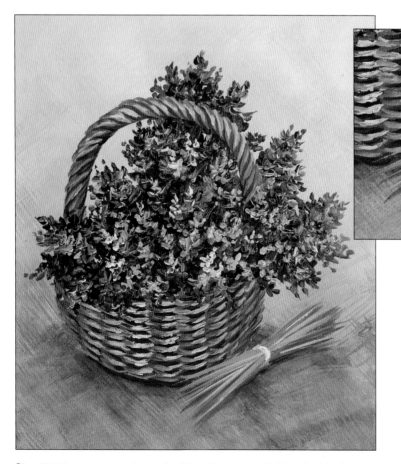

Step 7 Using sap green, ultramarine blue, pine gray, and white, I begin painting the stems of a lavender bouquet.

Step 8 Repeat step 5 to paint the first layer of lavender flowers.

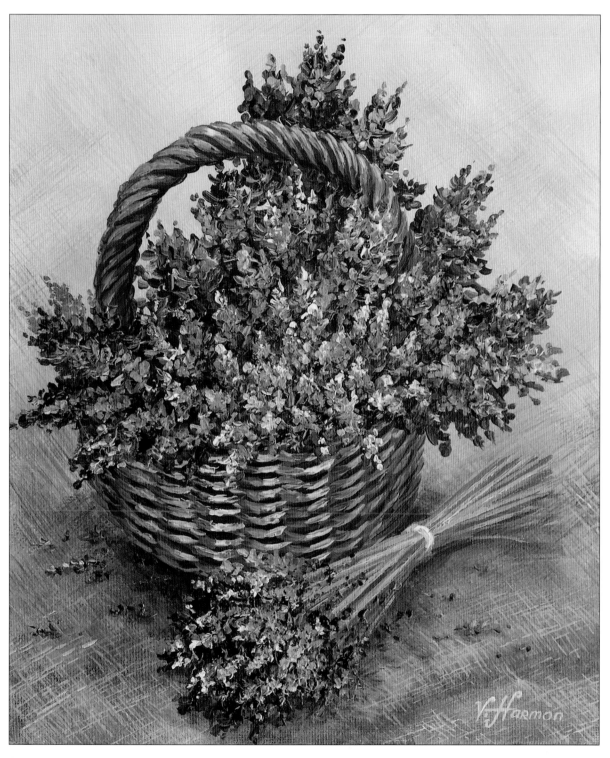

Step 9 Here I repeat the method used in step 6 to finish the flowers in the bouquet. I also create a shadow for the bouquet by applying a wash of ultramarine blue and pine gray on the fabric below the flowers. Finally, I add a few fallen petals on the fabric. The painting is now complete!

Magnolia *with Varvara Harmon*

When painting floral still lifes, it's common to work from the background toward the focal point in the foreground. But in this lesson, I demonstrate how the order can be reversed. You can start with the focal point (in this case, a magnolia flower in a vase), and complete your artwork by painting the background.

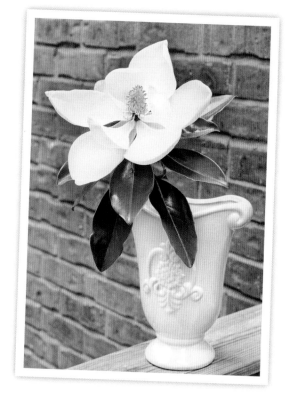

Color Palette

alizarin crimson • burnt sienna • cadmium yellow deep hue • sap green • titanium white ultramarine blue • Winsor lemon

Composition In the reference photo, the mortar seams in the brick wall and wood railing have a very large angle. I feel it's distracting to the eye, so I change it to a flat surface.

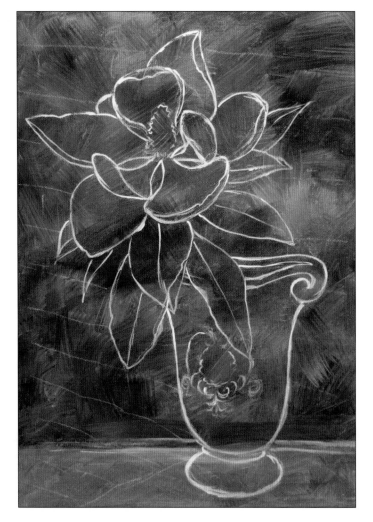

Step 1 Using a 1-inch-wide flat brush, I paint the background by placing a very thin layer of burnt sienna mixed with ultramarine blue. Then I draw the magnolia and vase with a white pencil. White shows the lines more clearly, but any color appropriate for the painting will work.

Artist's Tip

These underpaintings help establish the most important elements of the artwork: composition, value, and color theme. Make sure the first two steps are painted with a very thin layer of paint.

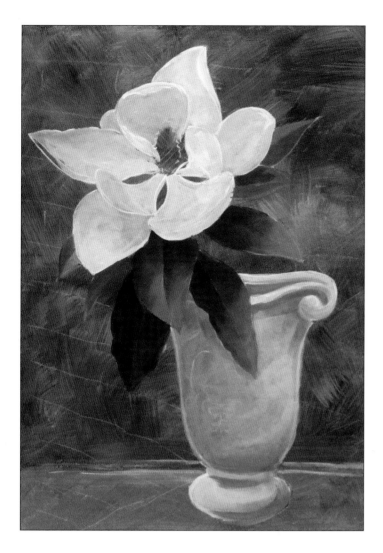

Step 2 I continue the underpainting by filling in my drawing of the magnolia flower with titanium white and adding a bit of ultramarine blue for the shaded area of the petals. For the leaves, I use sap green and add cadmium yellow to paint the lighter areas. The vase color is a mixture of titanium white, ultramarine blue, and a touch of burnt sienna.

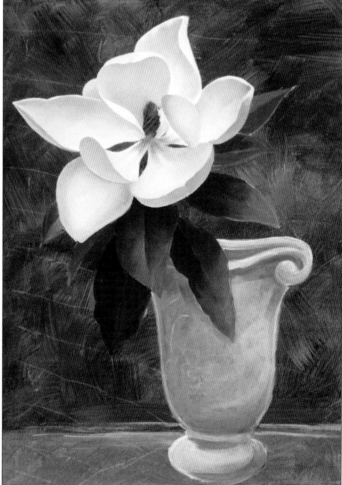

Step 3 Next I focus on the details of the magnolia flower using primarily titanium white with the addition of a little Winsor lemon in the lighter areas. To suggest the shaded area of the petals, I add ultramarine blue mixed with a hint of alizarin crimson. There is a slight reflection of yellow-green on the side of some petals facing the leaves. I re-create these reflections by adding a very small amount of sap green and cadmium yellow to titanium white.

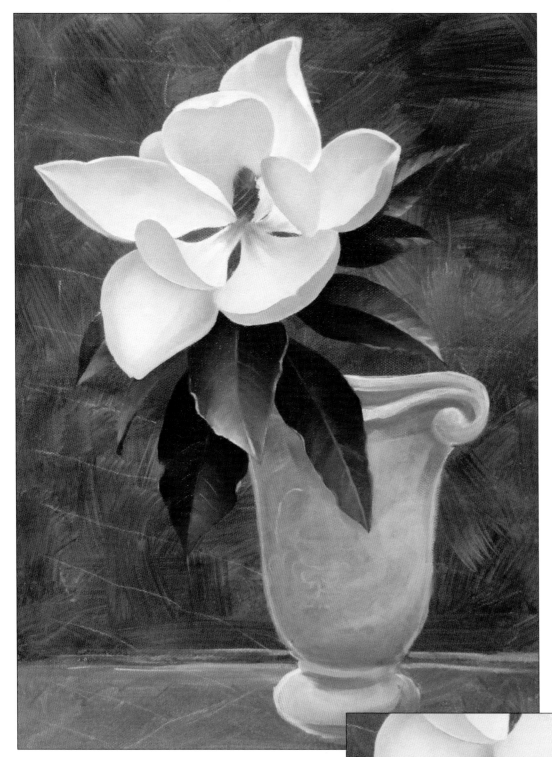

Step 4 I paint the shaded areas of the leaves with a mixture of sap green, ultramarine blue, and a small amount of burnt sienna. As I work toward the lighter area, I add more cadmium yellow. For the lightest areas of the leaves, I add Winsor lemon mixed with titanium white. I'll apply my final touches after I finish the background wall.

Step 5 Here I paint the stamen, or center part of the flower, in three short steps.

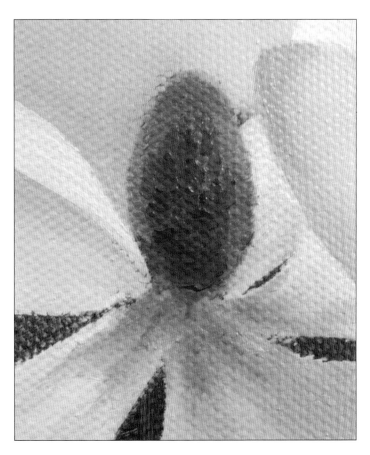

Step 5a First I paint the base shape of the stamen with a mixture of burnt sienna, sap green, and cadmium yellow.

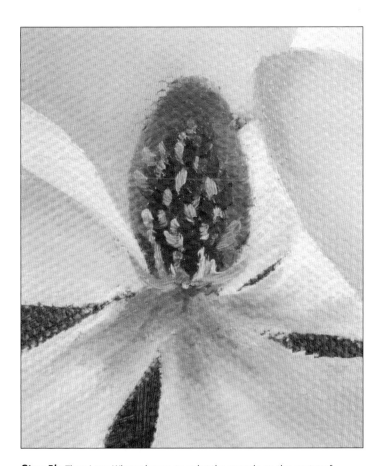

Step 5b Then I use Winsor lemon to paint the carpals on the center of the stamen.

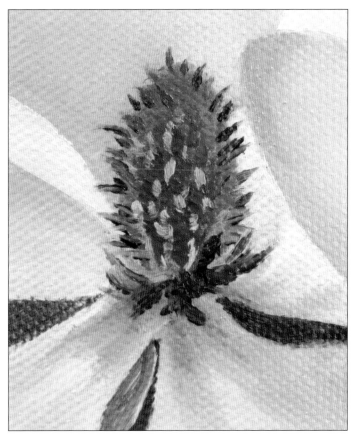

Step 5c As a finishing touch, I add darker strokes along the outline of the stamen using sap green and burnt sienna.

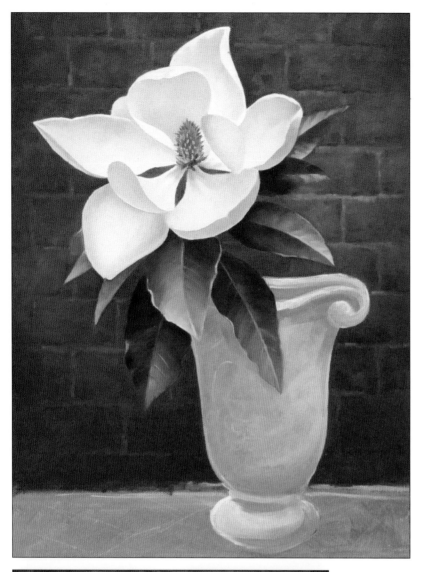

Step 6 Moving to the background, I paint the entire brick wall using ultramarine blue, burnt sienna, and alizarin crimson, along with a tiny bit of titanium white. I purposely do not mix these paints evenly in order to produce the interesting "patchy" effect on the wall. Next I add some detail to the bricks, including the mortar lines along the tops and sides, by mixing more white into the blend. I also paint a darker line along the bottom of the bricks to make them appear three-dimensional.

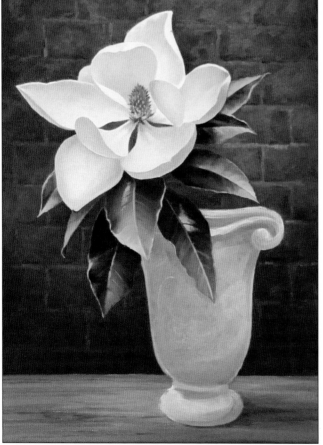

Step 7 I mix ultramarine blue, titanium white, and some burnt sienna to paint the weathered surface of the wood railing. To create the textured part of the wood, including the knots and cracks, I use less white paint in my mixture and apply it with the side edge of a flat brush. I also place some additional touches on the leaves to show more reflections.

Artist's Tip

If you begin your painting by working on the subject in the foreground, you need to be very careful when painting the background to avoid covering up areas you've already finished.

Step 8 Now I create the porcelain effect of the vase using a mixture of white, ultramarine blue, cadmium yellow, alizarin crimson, and a little bit of burnt sienna. I add a touch of sap green on the sides of the vase's rim, near the top, to show the reflections from the leaves.

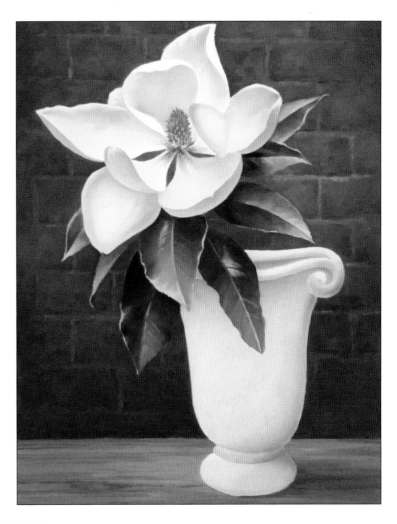

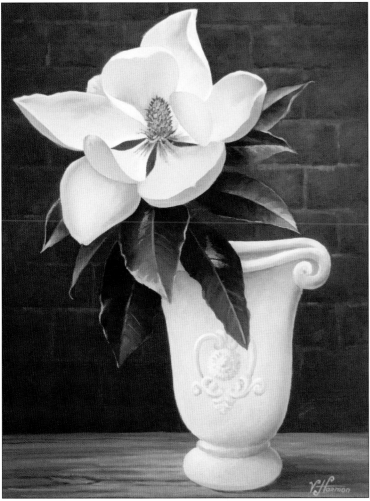

Step 9 For the final touch, I paint design details on the vase. I use a combination of white and cadmium yellow for the light sections of the design detail. For the midtone areas, I add alizarin crimson to the mixture. Lastly, I use a cool combination of ultramarine blue and white in the shaded areas.

Red Poppies *with Varvara Harmon*

To imbue the poppies in this still life with all the splendor they possess in real life, you must strike just the right balance between light and shadow. Keen observation is key. Spend time watching how light permeates flowers in nature and note how the direction of light creates contrast and dimension.

Color Palette

alizarin crimson • brown ochre • burnt sienna
cadmium yellow deep hue • sap green • scarlet lake
titanium white • ultramarine blue • Winsor lemon

Step 1 With a 1-inch-wide flat brush, I mix burnt sienna and ultramarine blue and paint a very thin background layer on a 16" x 20" canvas. Next, starting in the center, I paint a lighter area using more burnt sienna and a few subtle strokes of white. I add more ultramarine blue to make the value darker as I move away from the center.

Step 2 I set the composition by painting the vase and the poppy flower petals without focusing on too many details. If any changes to the composition need to be made, this is the time to make them. This first layer should be thin and will dry fast, allowing me to continue working on the painting in a day or two.

Step 3 Next I paint the primary layer for the large areas of the background, table, and vase. (These are merely the base colors; I'll add more detail later.) To finish the background I use a method similar to the one I used in step 1: I apply the same colors, leaving small areas uncovered for flower placement. However, now the background area will have smooth, blended color transitions. For the table, I use burnt sienna with ultramarine blue and white, adding more blue to create a grayish effect. I use the same three colors to paint the vase, but add a little brown ochre at the left to make that section appear lighter and warmer.

Artist's Tip

My palette for the vase is similar to the one I used for the background colors. The flower petals can be done with either alizarin crimson or scarlet lake.

Step 4 I use a mixture of alizarin crimson and scarlet lake to paint the shape of the poppies. The alizarin crimson is also used for the darker areas of the flowers. Next I add details to the vase. For the horizontal lines on the left side of the vase, I mix brown ochre and white, reducing the amount of white as I work toward the center. In the shaded area on the right side of the vase I replace brown ochre with ultramarine blue.

Detail

For instances of direct light hitting individual petals, I add a very fine line of white along the petal's edge and on its top surface.

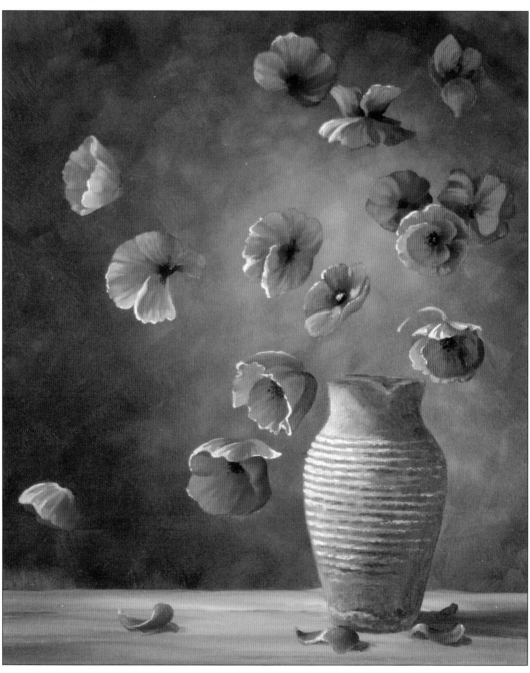

Step 5 To complete the poppies I shade the petals and darken the centers even more using a mixture of alizarin crimson and ultramarine blue. Then I mix scarlet lake and Winsor lemon to create the effect of light shining through the petals. I also add a few fallen petals on the table.

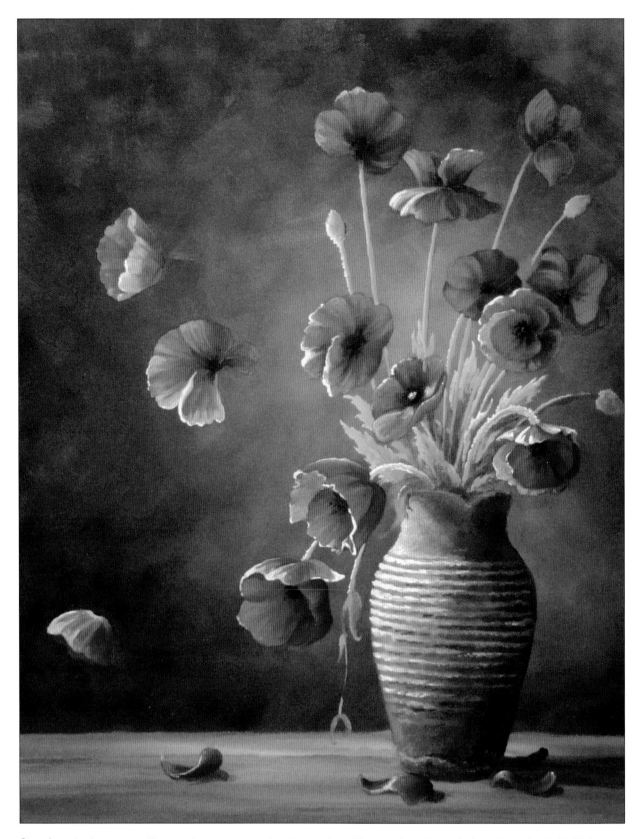

Step 6 I paint the stems and leaves using sap green as the primary color, adding titanium white and Winsor lemon for the highlights. For shaded areas I add ultramarine blue with a bit of burnt sienna to the sap green.

Artist's Tip

Because leaves and stems naturally fall in a variety of directions, the light reflections should also vary. Notice how the stems on the left are backlit. The light is evident on both sides of those stems, rather than only on the left side.

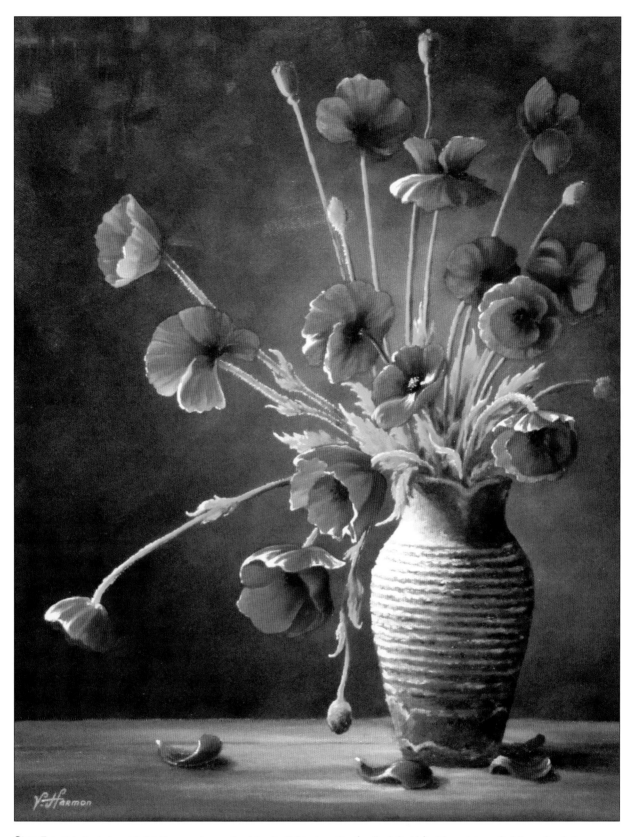

Step 7 In this final step, I finish the vase by emphasizing its lightest section (on the left side) with a mixture of white and cadmium yellow. Then I work on the same detail pattern on the shaded (right) side by painting lines with a mixture of white and ultramarine blue. To add more contrast to the vase's shape, I apply a few strokes of a darker mixture of burnt sienna and ultramarine blue along the shaded side.

Artist's Tip

Adding yellow color to a light area creates a warm effect, whereas applying blue shades to areas in shadow has a cooling effect. Be aware that in a shaded area the color value should be a few tones darker than in a light area.

Zinnias *with Varvara Harmon*

Painting zinnias is an enjoyable, but challenging exercise that if done well, will result in a final portrait that is as delightful as a basket of fresh-cut flowers. Not only must each flower stand out from the rest, but each petal among the layers must be defined and highlighted to capture the true beauty of the flower.

Color Palette
alizarin crimson • burnt sienna • burnt umber
medium cadmium yellow • sap green • titanium white
ultramarine blue • yellow ochre

Step 1 I paint the first layer of the background onto my 12" x 12" canvas using yellow ochre, burnt sienna, and titanium white. I intentionally don't mix the colors thoroughly so the vertical strokes of the background show.

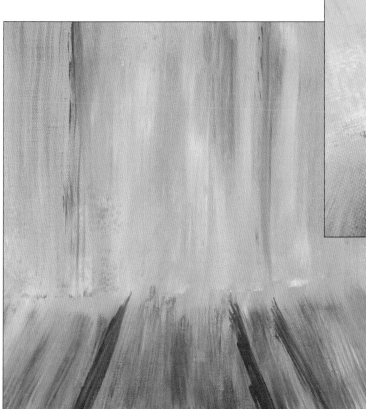

Step 2 To create the effect of weathered green paint on the wall, I mix ultramarine blue and sap green, adding a bit of titanium white. I don't add water to this mixture to keep it relatively dry. After the first layer dries, I place the vertical strokes by dragging the brush, barely touching the canvas, from the top down to the line indicating the tabletop.

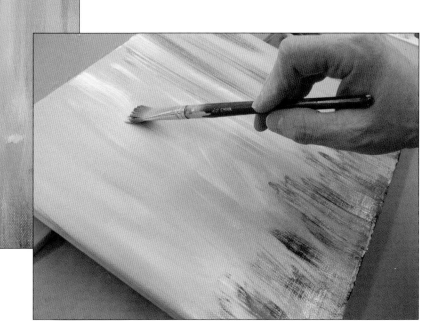

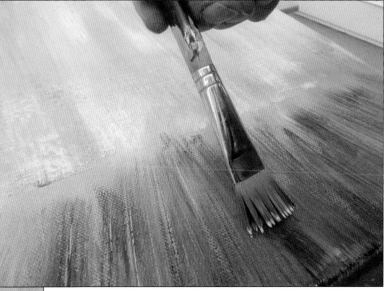

Step 3 Here I combine burnt umber and ultramarine blue to paint the darker lines that add texture to the wood table. To maintain proper perspective, I place my strokes slightly toward the center as I move to the back of the table.

Step 4 Using a 1-inch flat brush loaded with a mixture of titanium white and a bit of ultramarine blue and burnt umber, I paint the wooden basket by applying strokes from left to right to show its shape. (The direction of strokes depends on what is most comfortable for you.) To add texture to the basket, I use more burnt umber in the mixture. The top of the basket should be darker to represent the shade from the flowers.

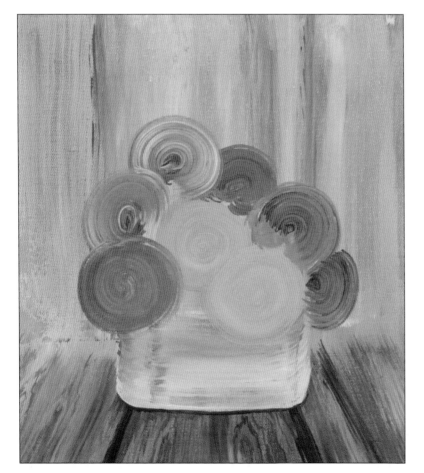

Step 5 I quickly map out the flowers in the basket by making circular strokes with my 1-inch brush. I use alizarin crimson and titanium white for the pink zinnias and medium cadmium yellow for the yellow flowers.

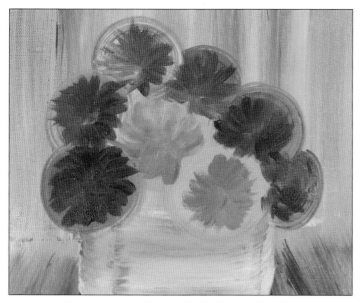

Step 6a To paint the pink and purple zinnias, I mix alizarin crimson, ultramarine blue, and titanium white. Adding strokes in darker colors to the centers of the pink flowers provides contrast for the lighter petals I'll paint in the next few steps.

Step 6b Next I begin painting the bottom petals using a ¼-inch-wide flat brush with rounded corners and the same combination of alizarin crimson, ultramarine blue, and titanium white.

Step 6c For the next layer of petals I add a little more white to the same color mixture.

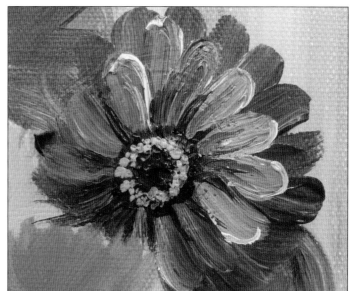

Step 6d I add burnt umber to the alizarin crimson and ultramarine blue mixture and paint the center of the flower. Then I place tiny dots of medium cadmium yellow over the burnt umber to indicate the stamens.

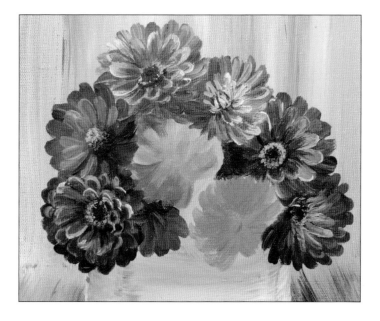

Step 7 I repeat the entirety of step 6. For the purple zinnias, I simply add more ultramarine blue to the color mixture

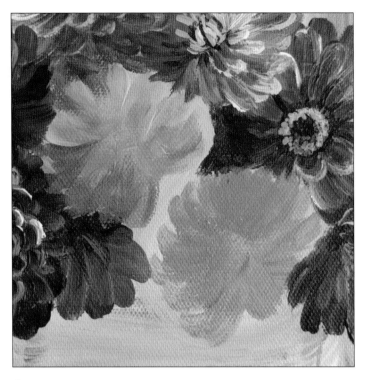

Step 8a With a mixture of medium cadmium yellow, yellow ochre, alizarin crimson, and titanium white, I begin painting the yellow and orange zinnias. Starting at the center of the flower I apply darker strokes by mixing medium cadmium yellow and yellow ochre for the top yellow flower. Then I add a little alizarin crimson to paint the bottom flower.

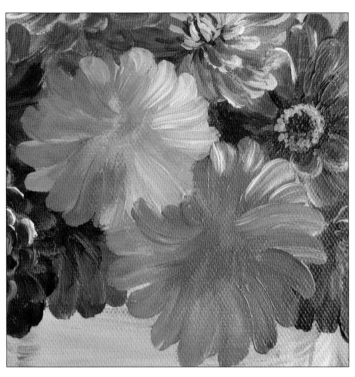

Step 8b Next I use a similar color combination to paint the base petals of both yellow flowers.

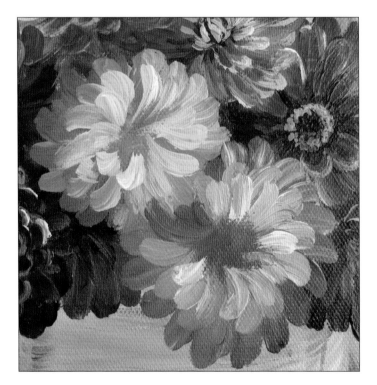

Step 8c I create more layers of petals by placing them above the previous layer and adding titanium white to the yellow and orange mixture.

Step 8d As in step 6, I add burnt umber to my working mixture and paint the center of the flower. Then I place tiny dots of medium cadmium yellow over the burnt umber to indicate the stamens.

Step 8e To create the highlights I add a few very fine lines along the edges of the top petals using titanium white.

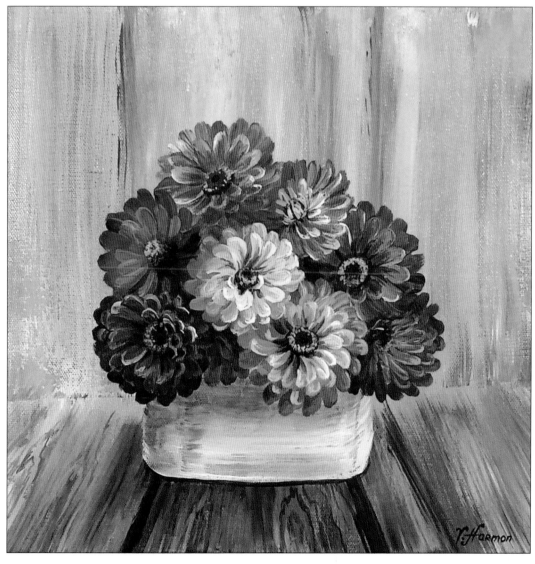

Step 9 This beautiful basket of zinnias is now finished!

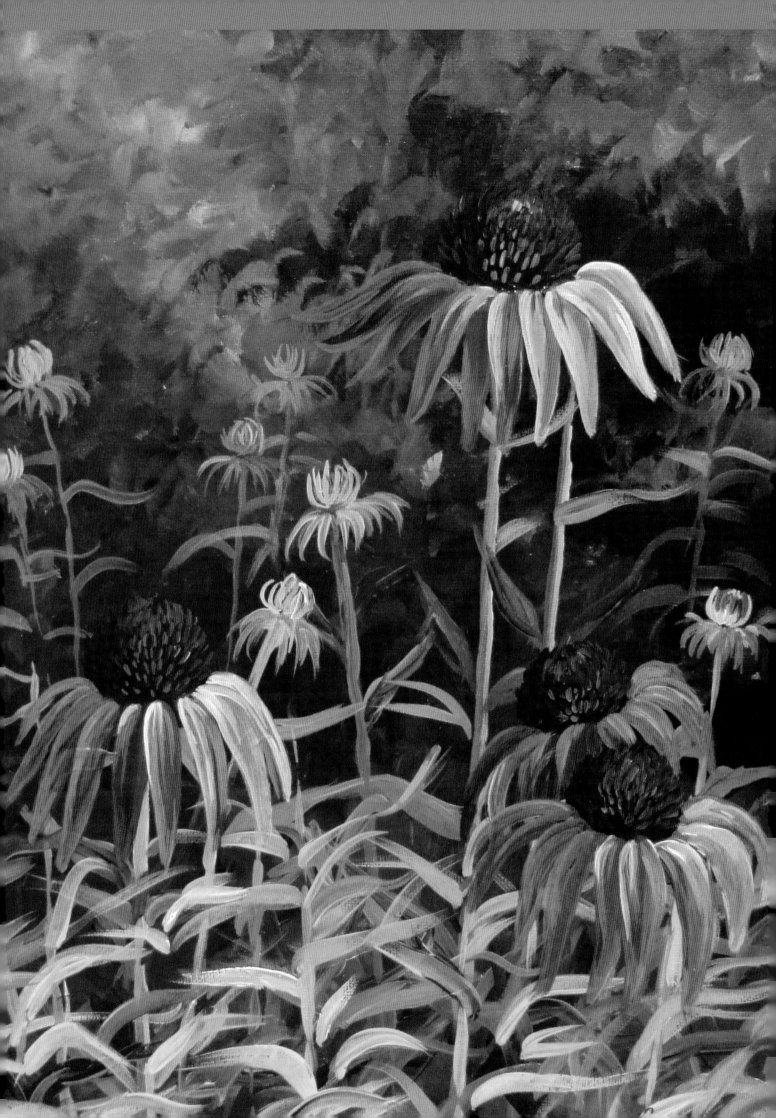

CHAPTER 4

Wildflowers

with David Lloyd Glover and Varvara Harmon

There is nothing quite as romantic as a hillside blanketed in blossoms or a secret pathway shrouded by overgrown wildflowers the color of jewels. In this chapter, you'll bring bucolic scenes like these to life, infusing them with rich color using a surprisingly basic palette. You'll learn how applying just the right tone in your underpainting will make the final artwork absolutely striking. And you'll gain insight into one of the most important skills an artist can develop—how to take artistic license. With all this knowledge and more, the projects that follow will soon evolve from practice pieces to masterpieces.

Anemones *with David Lloyd Glover*

This depiction of spring flowers growing wild under the sun's warm rays uses a basic palette and is fun to paint. Throughout the project, we'll focus on creating dimension using natural light patterns and adding details that will bring this meadow to life.

Step 1 I begin by applying a light wash of primary red onto my 20" x 16" stretched canvas to establish a bright pink background. Pink will enhance the colors in the predominantly green meadow scene. Next I create a quick sketch using a #4 flat bristle brush dipped in a thin mix of ultramarine blue and dioxazine purple. I look for the basic shapes in the scene and establish their compositional layout. It isn't important to draw too many details at this stage; focus instead on the main areas of light and shade.

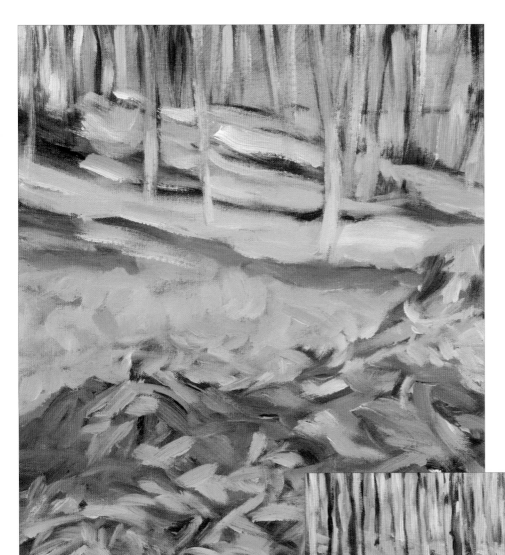

Step 2 I set up my palette with ultramarine blue, phthalo blue, dioxazine purple, cadmium yellow light, and titanium white. Using blues to mix the greens of the foliage makes it easier to control the cool colors of the shaded areas. I increase the yellow in the mix when I want to indicate areas where sunlight alters the color. Notice how the brushstrokes mimic the direction and flow of the leaves. I use loose downward brushstrokes to quickly place the tree trunks.

Step 3 Now I add cadmium yellow medium to the palette. Using a #9 flat bristle brush loaded with lots of warm greens, I add more layers of color with loose brushstrokes to highlight the sun-kissed tips of the anemone leaves. Then I work the cool blue-greens into the shaded areas. I further define the stand of trees with a #8 flat bristle brush and a mixture of cadmium red light, cadmium yellow, and titanium white. To shape the trunks I add a few edges with a #5 flat bristle brush loaded with dioxazine purple. I avoid putting in too much detail to prevent the tree line from becoming the focus of the painting. Lastly, I use a mixture of ultramarine blue and white to loosely suggest the sky appearing between the trees.

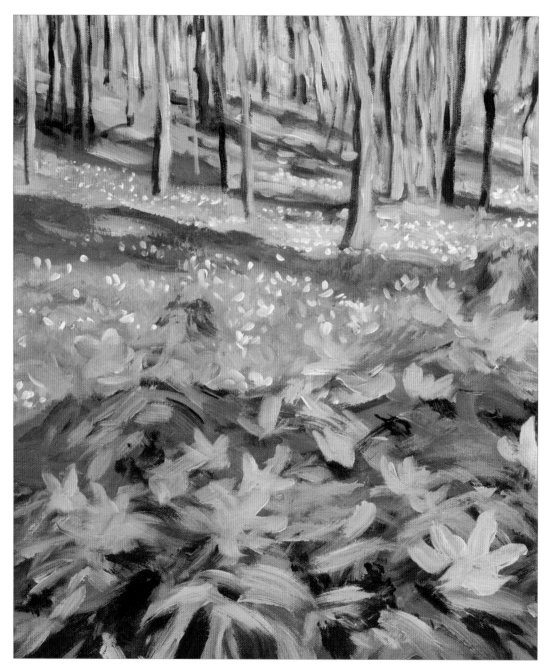

Step 4 In this step, I position the anemones atop the layers of foliage color. With a #7 flat bristle brush and a mixture of ultramarine blue, a touch of dioxazine purple, and a bit of titanium white, I suggest the anemone blossoms with loose brushstrokes. Then I dab some white and blue mix with the edge of the brush to show anemones in the distance. The flowers in the shaded area are mostly blue. In the sunnier patches they're pure white.

Anemones Detail

Here I use a #5 flat bristle brush and pure titanium white to create the bright highlights on the anemone flower petals. A flat brush helps produce softer edges on your details. Feel free to use a round bristle brush if it feels more comfortable.

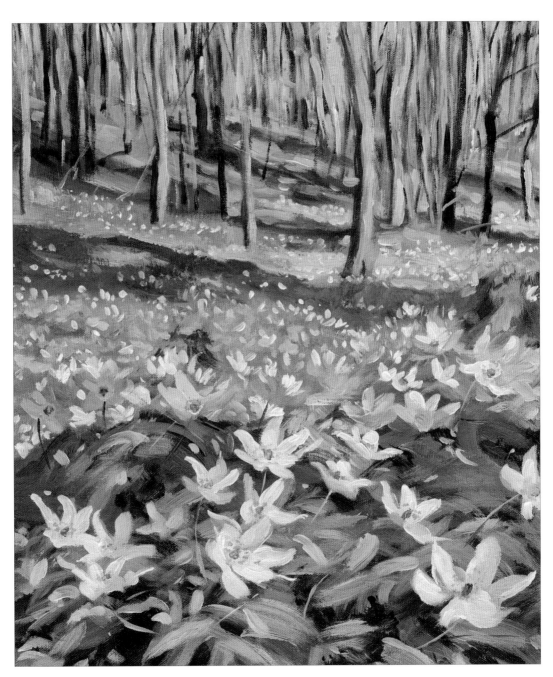

Step 5 I want to retain the painting's impressionistic feel as I finish the details, so I keep my brushstrokes loose and expressive with soft edges. I use pure titanium white where the sun highlights the anemone petals. In some areas of the flower I either leave the blue background or lightly layer on white to shape the petals. In areas where I want to show some brightness in the leaves, I add bright yellow-green. I also use bright tones on some of the tree trunks to give them a slight glow, and then add a few more branches to give the illusion of detail. To complete the painting, I add some stems and dab in the buttons and stamens to the flowers.

Cosmos *with David Lloyd Glover*

Painting this simple garden pathway blooming with cosmos and dappled with warm afternoon light will stretch the imagination of both you and the viewer.

Color Palette

cadmium red • cadmium red light • cadmium yellow dark cadmium yellow light • dioxazine purple • phthalo blue primary red • quinacridone magenta titanium white • ultramarine blue

Step 1 First I prep my pre-stretched 20" x 16" canvas with an underpainting wash of cadmium red light. This background will help give the foliage greens more vibrancy in your finished painting. Next I use a thinned dioxazine purple and a brush to create a quick outline. The sketch is merely to indicate where the key compositional elements are located on the painting. Don't worry about the finer details at this stage.

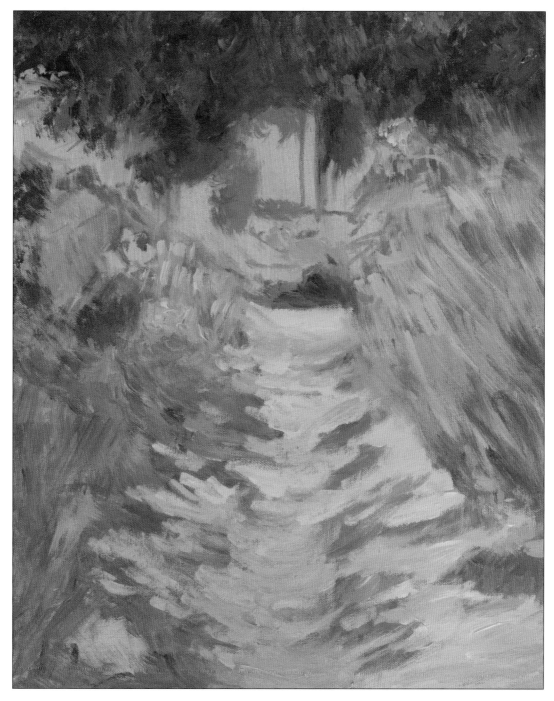

Step 2 Using a palette of dioxazine purple, ultramarine blue, phthalo blue, quinacridone magenta, and titanium white, I mix deep tones of cool colors. Then I loosely block in the shadow areas with a 1½-inch bristle brush. Notice how the brushstrokes flow in the same direction the foliage grows. I continue by roughing in the pathway with a #5 flat bristle brush and a mixture of dioxazine purple, cadmium yellow dark, and titanium white.

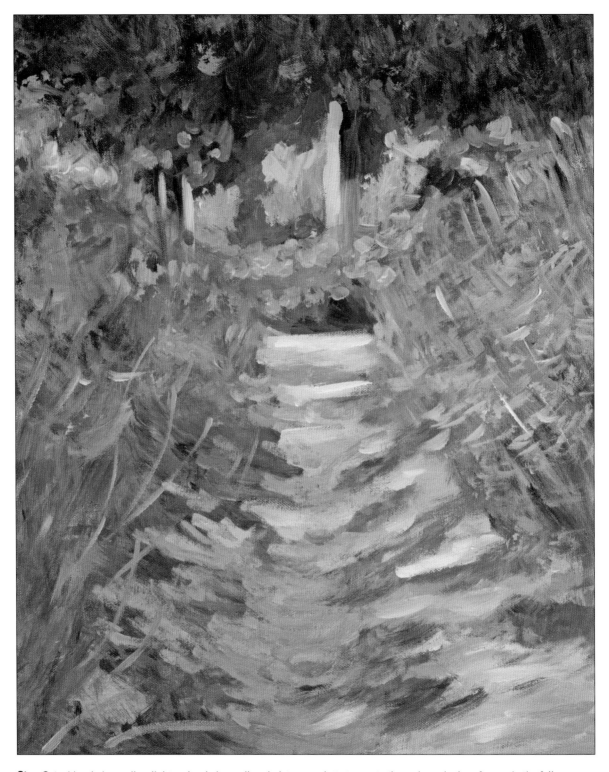

Step 3 I add cadmium yellow light and cadmium yellow dark to my palette to create the various shades of green in the foliage along the footpath. Then I blend ultramarine blue with cadmium yellow dark for the deep olive greens that suggest the heavy tree growth in the upper background. With some loose strokes of light tones, I begin to mark in the areas where I want sunlight to fall on the pathway. Although the painting is still sketchy, the direction in which it is heading is evident.

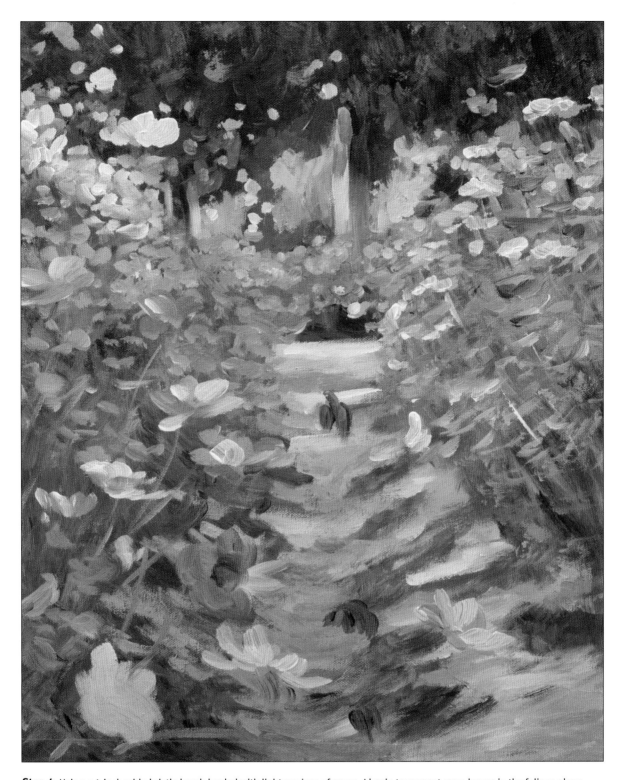

Step 4 Using a 1-inch-wide bristle brush loaded with lighter mixes of green, I begin to suggest more leaves in the foliage along the pathway. The lighter greens will mark the places through which the sunlight filters. In the background, I brush in some loose depictions of the flower beds with cadmium yellow dark blended with a touch of cadmium red. My brushstrokes and color are painterly and not too tight. Now I'm ready to block in the clusters of cosmos by adding my floral pigments to the palette. Primary red and quinacridone magenta make for bright floral pinks. With quick strokes of the brush loaded with color, I fill in the areas where all the blossoms sprout. A blend of dioxazine purple and quinacridone magenta makes a mauve shade that complements the pink cosmos. Then I brighten the yellow flowers with cadmium yellow and titanium white.

Artist's Tip

One of the best things about painting a flower garden is that you can create a successful artwork by employing the imagination of your viewers. Let them fill in many of the details using their unique "mind's eye."

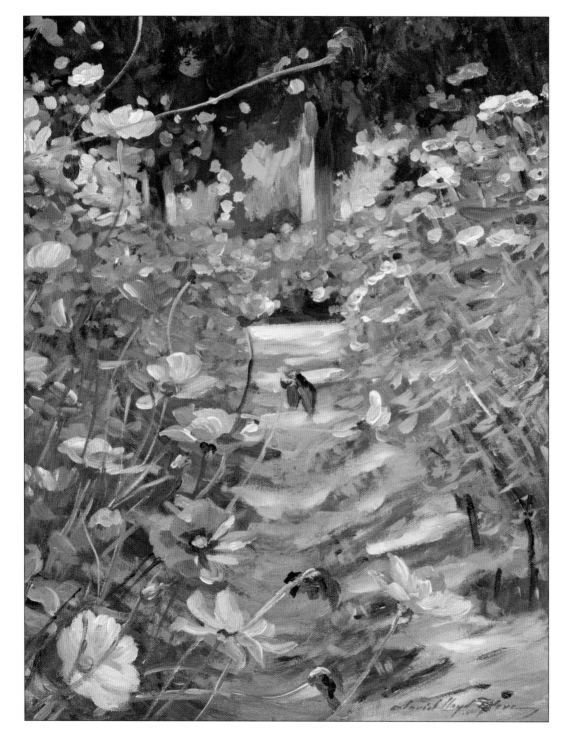

Step 5 This is an excellent point to paint in details of flowers, stems, leaves, and the pathway. I like to keep the painting loose, with an impressionistic feel, so the finishing elements are more suggestive than the fine line details. Next I brighten the pathway with brushstrokes of sunlight and then indicate highlights on the tree trunks. I also finish some of the blossoms caught by the light with tones that are predominantly titanium white. From afar, this little painting appears dimensional, with the distance created by the differences in color temperature. Up close, it has an artistic flair that makes for an engaging garden painting.

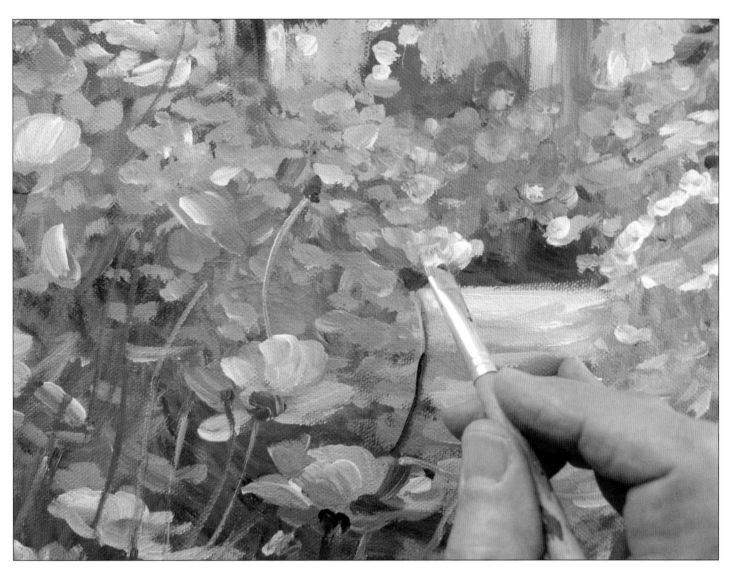

Step 6 Don't forget to have fun while you're busy adding details to your painting. Dabbing some primary red on the cosmos flower in the bottom half of the composition creates a foreground focal point. And making a few blossoms brighter helps them stand out in the composition. I blend color right on the canvas by mixing magenta and titanium white as I paint with a brush loaded with both colors.

Artist's Tip

Remember that with oil and acrylics you paint "light over dark" colors and "fat over lean" density of paint.

Foxgloves *with David Lloyd Glover*

There's nothing that typifies an authentic English garden in the summertime quite like a patch of tall, delicate foxgloves. These splendid flowers bloom in a variety of colors, but for this project we'll do the main stalk in lavender and another in white.

<div style="border:1px solid">

Color Palette

cadmium yellow • cadmium yellow dark • dioxazine purple
phthalo blue • primary red • quinacridone magenta
titanium white • ultramarine blue • yellow ochre

Additional: acrylic modeling paste

</div>

Step 1 First I lay down a surface on the canvas that will help create a pleasing brushstroke later. Using a painter's spatula I apply acrylic modeling paste, keeping the paper moist with a water sprayer for workability. Then I create random crosshatched brushstrokes all over the surface with a 1-inch gesso brush and let it dry completely for a few hours.

Step 2 I prep my pre-stretched 16" x 20" canvas with an underpainting of a wash of yellow ochre blended with cadmium yellow to brighten the color. Then, using a thinned dioxazine purple on my brush, I create a quick outline. My goal is to place the two foxgloves and establish the shapes of their mass, as well as the composition of garden greenery. The drawing is sketchy and not necessarily accurate, but it's good enough for adding color.

Step 3 Next I set up a palette of dioxazine purple, ultramarine blue, phthalo blue, cadmium yellow, and titanium white. After mixing deep tones of green, I use a ½-inch bristle brush to block in the leafy areas. I leave the foxglove trumpets blank so I can visually balance the shape of the flowers with the background.

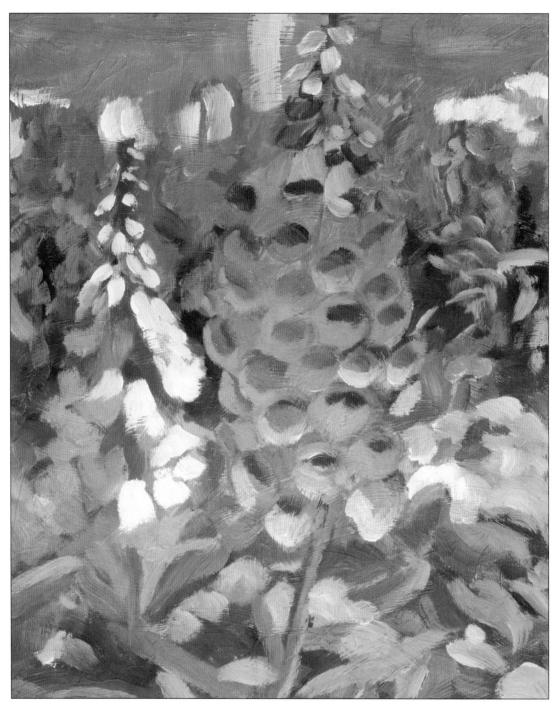

Step 4 I add my flower colors, quinacridone magenta, primary red, cadmium yellow dark, and titanium white, to the palette. Then I paint more foliage shapes with lighter green tones created by adding cadmium yellow and white to phthalo blue. I use a wide bristle brush and loose, expressive brushstrokes to paint the leaves. Painting from dark to light is fun because you can layer brighter colors to bring different forms forward, while the shadows recede, creating a sense of depth. Notice how the texture creates a surface tooth that grabs the paint off the brush and produces interesting edges.

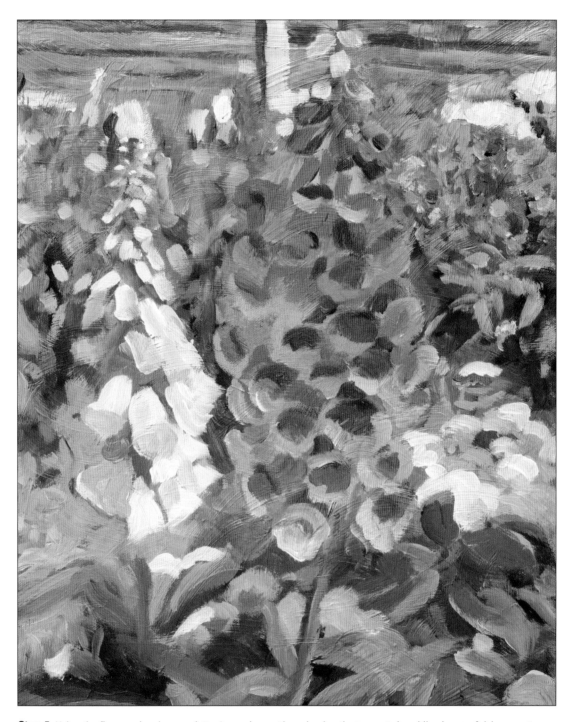

Step 5 Using the flower colors in my palette, I spend more time shaping the trumpets by adding layers of rich, warm tones. The more I build up the color depth and shape of the foxgloves, the more they appear to come forward in the painting.

Artist's Tip

To ensure your flowers look lifelike, always be aware of your light source. The shape of a flower is all about how the sunlight hits the flower petal. Shadows and reflections further define the shape.

Foxgloves Details

The only elements of the painting I really add detail to are the lower flower trumpets. That is where I want to direct the visual focus. The viewer and the visual illusion the painting creates will add the finer details for you.

Detail 1

I use pure titanium white to bring out the highlights on the smaller foxglove and let the darker areas of the background help shape the blooms. This really pushes the flowers forward in the composition. Note that the edges are soft and feathered.

Detail 2

For the bells, I use a lavender color made with a mixture of dioxazine purple and white. I load my brush with white on one side and the color mixture on the other. This way I can create light and dark color simply by turning the brush in a single stroke. The details of each flower require only a few brushstrokes, but feel free to add as much detail as you want.

Detail 3

Notice how the textured layer on the canvas produces interesting edges in your painting. You'll also find that the randomness of the underlying texture results in nice surprises as you brush on color.

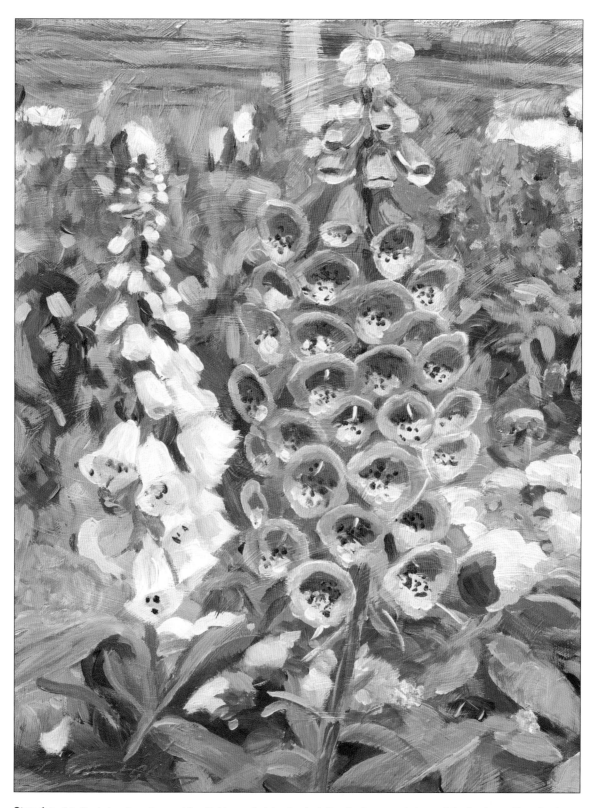

Step 6 In this final step, I continue adding light over dark to clearly define the leaves and stems of the foxgloves. To maintain the impressionistic style of this painting I loosely suggest the background garden elements. The texture of the garden fence is created by scumbling the brush across the surface in the direction of the boards with different layers of color. The large foxglove is framed by a background of vivid blue flowers that are rendered with rough brushstrokes rather than sharp detail. This helps bring the foxgloves forward and makes them the focal point of the painting when viewed from a distance.

Water Lilies *with David Lloyd Glover*

Water lily paintings are popular among art enthusiasts and they're also fun to paint. To add interest to this serene setting of a water garden filled with lily pads and colorful blooms we will add the effect of rainfall.

Color Palette

cadmium red medium • cadmium yellow • dioxazine purple
phthalo blue • primary red • quinacridone magenta
titanium white • ultramarine blue

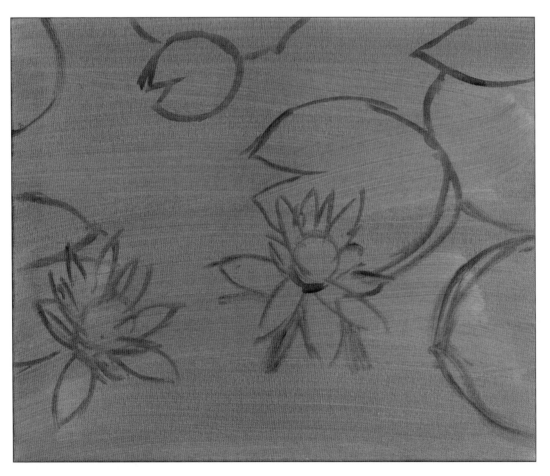

Step 1 First I prep my pre-stretched 16" x 20" canvas by doing an underpainting with a wash of primary red. This background will make the blues of the pond and the greens of the lily pads "pop." Next I use a thinned dioxazine purple to create a quick outline with my brush. The sketch indicates where I want to position the lily pads within the composition. I also rough in the blooming lilies. Note that I put the point of interest below the centerline of the painting. Doing so will ultimately make this simple painting more dynamic.

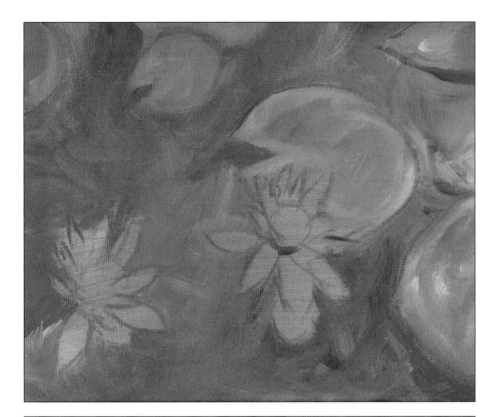

Step 2 With a palette of dioxazine purple, ultramarine blue, phthalo blue, cadmium yellow, and titanium white, I mix some deep tones of cool colors. I use a wide bristle brush for the initial blocking of color. This helps establish the compositional elements and offers a glimpse of how the painting will develop.

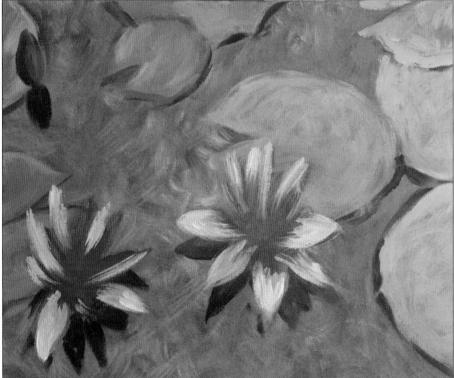

Step 3 I add cadmium red medium and quinacridone magenta to the palette and start to build layers with a short-handled 1-inch bristle brush. Then I layer different colors in the pond using several mixtures of blue tones and other tones in the purple family. Because acrylic dries quickly you can create overlapping layers to build and deepen your colors. I use the same method of building up layers for the lily pads, which makes large areas of green tones more varied and interesting to the eye than if they were solid green. Next I rough in the bloom colors, adding some brushstrokes of deep color where the shadows of the blooms would be and around the edges of the lily pads.

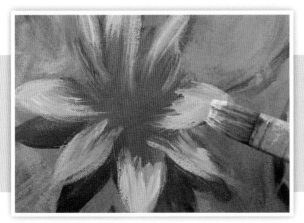

Water Lily Detail

To indicate the water lily petals I use a 1-inch brush loaded with a mixture of titanium white and cadmium red medium. Notice how the edges are soft and feathered.

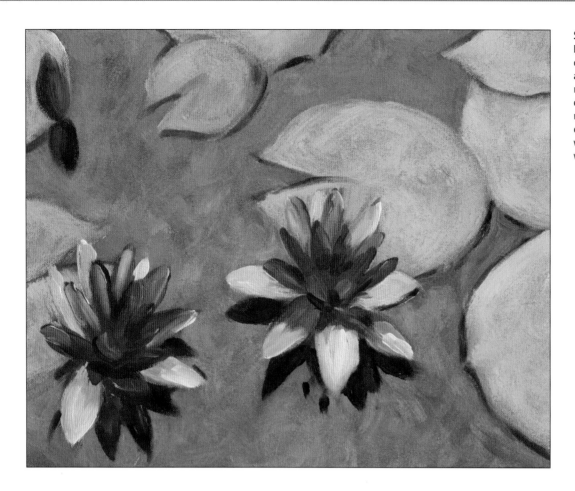

Step 4 Using a 1-inch bristle brush, I continue to layer tones of color that give the elements depth and form. The lily pads become more modeled and the reflections on the water and its depth become more apparent. By changing the direction of brushstrokes, I give the water a sense of movement, which would be present on a rainy day.

Rain Droplets Detail

Painting rain droplets is really quite simple. I outline the droplet with a deeper tone of my background color to define the droplet's shape. Here I use a #4 round brush loaded with the deeper green. Then I use a middle tone to create the illusion of a dome shape. Finally, I use white to add a highlight reflected from the light source.

Stamen Detail

I add the stamen using the edge of a #2 flat bristle brush loaded with cadmium yellow and a touch of white to make the color brighter. This is an impressionist painting, so I merely suggest the details.

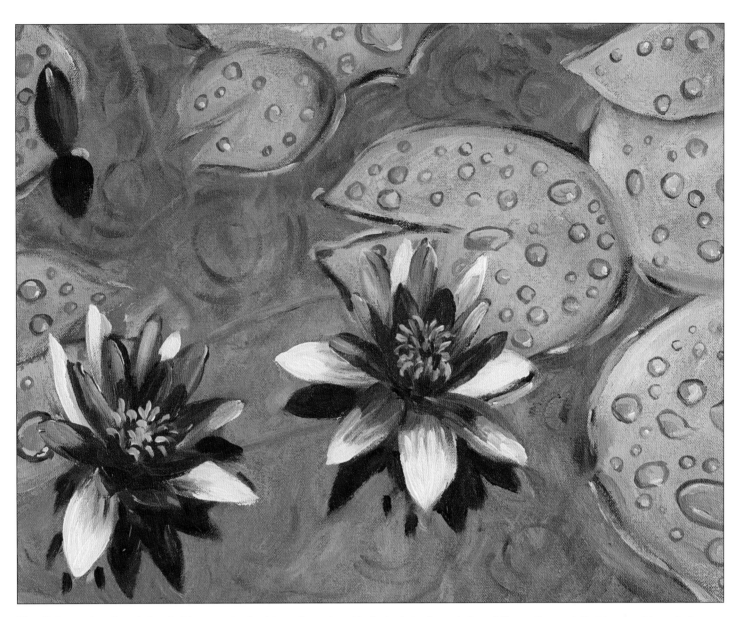

Step 5 To complete the painting, I add more water droplets on the pads and indicate circles from raindrops falling on the pond. Next I use a mixture of primary red and white to add some deep red to the blossoms. I also add underwater stems to give the pond even more depth. Have fun adding as many small details as you like at this point. Now that the painting is complete, you can see how placing one of the blooms off center and the main bloom below the painting's centerline has created the illusion of distance. Otherwise the painting might have looked too flat.

Artist's Tip

Painting flowers in acrylic will have more of an impact if you keep the edges of the petals soft. You can achieve the effect by using a little less paint and letting the brush create the edges for you.

Echinacea *with Varvara Harmon*

Painting wildflowers is fun! They provide an endless array of colors, shapes, and compositions to experiment with. I really like this photo of pink Echinacea flowers, but it's a little busy. As the artist, you have the freedom to change or tweak your painting—you don't have to paint exactly what you see! I decide to focus on four main flowers.

Color Palette

alizarin crimson • burnt sienna • cadmium yellow medium
sap green • titanium white • ultramarine blue • yellow ochre

Step 1 I establish the composition by drawing the flowers to determine the placement of each blossom. I do not add any other details because I'm going to cover the canvas with an underpainting. If you want more details, draw them on a separate piece of paper to use as a guide.

Step 2 I lay down my first background layer with a big flat brush, using ultramarine blue, yellow ochre, burnt sienna, and sap green. I cover the whole background, just leaving small spaces for the centers of the flowers.

Step 3 I finish the background with a second layer, using all the same colors but adding cadmium yellow medium and titanium white to create lighter values. I use a medium flat brush as well as round brushes to create the soft background forest and grass effect.

Step 4 I add the stems and leaves, using a few different medium- and small-sized round brushes and various mixtures of cadmium yellow and sap green to achieve depth and variety. I use a lighter mix for the stems and leaves in the foreground and darker mixes for the flowers toward the back, so they appear to recede into the background. Then I add a few small buds to some of the stems.

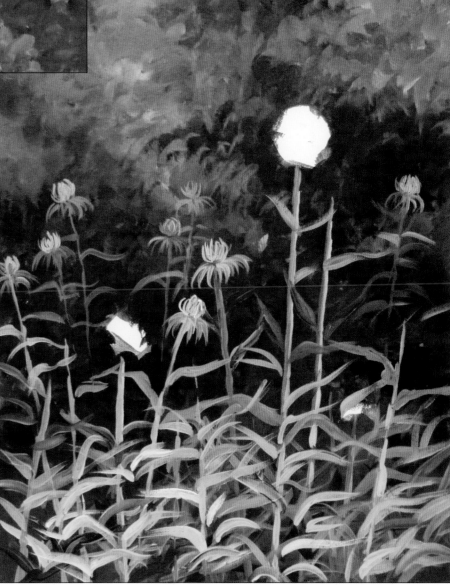

Painting the Buds

Step 1 I use a small round brush to paint the top of the bud with a mixture of cadmium yellow medium and sap green with titanium white.

Step 2 Then I add a couple of strokes with a mixture of alizarin crimson and titanium white to emphasize the color of future petals.

Step 3 Lastly, I add some small leaves below the flower bud, using a mix of cadmium yellow medium and some sap green.

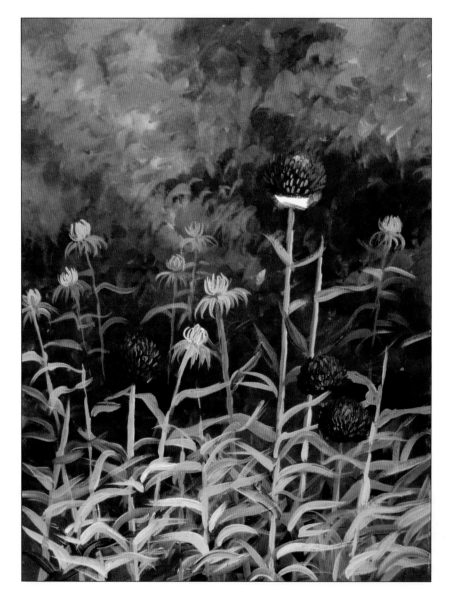

Step 5 Next I paint the base color of the flowers' centers, using a combination of alizarin crimson, burnt sienna, and ultramarine blue. I use more burnt sienna and ultramarine blue on the shadow side of each center. Then I paint the stamens with a fine round brush, using alizarin crimson, burnt sienna, cadmium yellow medium, and titanium white. I use short strokes and leave space between the stamens so the base color shows through.

Step 6 Next I place the base color of the flower petals. On the sunlit side, I use a mixture of alizarin crimson and titanium white. For the parts in shadow, I add ultramarine blue to my mix and use less titanium white.

Step 7 I finish by adding more details to the flower petals and emphasizing the shadows and highlights. For the shaded parts I lay on more alizarin crimson and ultramarine blue. For the highlights I use a cool mix of titanium white and ultramarine blue. To bring out the highlights on the sunlit side I use a warm mix of titanium white and cadmium yellow medium. I just use a few strokes, letting my base color show for dimension.

About the Artists

Marcia Baldwin is an award-winning contemporary fine artist, born and raised in Louisiana. Throughout her childhood, Marcia's parents and grandmother encouraged her to explore her creativity through drawing, painting, sewing, and crafting. After earning a BA in fine art, she continued to take graduate courses at Louisiana State University. She has taught all different age levels, ranging from kindergarten through college and adult education. Currently, she is the owner of M. Baldwin Fine Art Originals, Inc. After 37 years of professional growth, Marcia continues to challenge herself creatively by approaching each new painting as a journey, an exploration, and a moment to discover something new and wonderful. It is her love of art—the passion she hopes to share with each person that sets eyes on her work—that drives her. Each day she is thankful for her talent and blessings from God. With the support of her family and her two grown daughters, Marcia continues her journey as a lover of art. Visit www.mbaldwinfineart.com to learn more.

David Lloyd Glover was trained as an artist starting at the Victoria School of Fine Art while still in elementary school. David began working as a full-time editorial illustrator after high school and was mentored by the noted Canadian artist and cartoonist, Sid Barron. David had six illustrations published weekly by a major daily newspaper for five years. He then turned his illustration skills and discipline into a successful career in the graphic arts and advertising industry, gradually shifting to exclusively producing gallery artwork. For the past 28 years, David has been a full-time fine artist creating original works in watercolor, oil, and acrylic for galleries and fine-art publishers internationally. His subject matter is wide ranging, and his techniques are equally as varied. Learn more about David by visiting www.davidglover.com.

Varvara Harmon is an award-winning multimedia artist who works with oil, acrylic, watercolor, silk paintings, and ink and pencil drawings. Her work has been juried into national and international exhibitions and is in private collections around the world. Varvara's work has been published in *International Artist* and *American Artist* magazines, as well as in *The Best of America Oil Artists* book in 2009 and *The Best of World Landscape Artists* in 2012. Born and raised in Volzshk, a small Russian city in central-European Russia, Varvara began painting as a child and studied at the Volzshk Art School, where she graduated with a Diploma in Art Studies. She immigrated to the U.S. in 2001 and lives in Maine, where she is daily inspired by the beauty of the land, inland waters, coast, and people. Varvara is currently represented at several art galleries across the Northeast and teaches workshops and classes in acrylic, watercolor, and oil. Visit www.varvaraharmon.com to learn more.

Judy Leila Schafers is self-taught through years of studio practice, close observation of nature, advice from other artists, and a curiosity to learn more about the natural world. A love for the land in which she was born has led Judy on a personal 38-year journey of artistic discovery through the medium of acrylic. She believes that much can be learned about painting by experimenting, paying attention to details, and learning how to see. She is active in her local arts community, serving on the boards of several non-profit art societies and guilds. Judy lives on a busy grain farm west of Edmonton, Alberta, where she owns and operates her studio and gallery, hosts annual art events, and teaches art lessons. Her work has won numerous awards and is held in private collections on several continents. She is currently represented at the Daffodil Gallery in Edmonton, Alberta. Visit www.judyleilaschafersfineart.com to learn more.

James Sulkowski is a classical artist in the tradition of the Masters. His adherence to Old Master concepts and techniques gives his work both timeless and luminous qualities. His dramatic effects of light and use of deep, rich color have attracted private, corporate, and public collectors worldwide, including former President George H.W. Bush, the Saudi Arabian Royal Family, and the Metropolitan Opera of New York. James studied at the famed Pennsylvania Academy of the Fine Arts, at Carnegie-Mellon University, and most notably with master artist Frank Mason at the Art Students League of New York. Among his many awards is the Helen DeCozen Award for Best Floral Painting. James feels that teaching is an integral part of his artistic life and he loves to teach his national workshops. Learn more about James at www.jamessulkowski.com.

Index